YESTERDAY'S
CARDIFF
REVISITED

BRIAN LEE & AMANDA HARVEY

The
History
Press

In memory of our lovely neighbour Lynne-Marie McCormack

First published 2013

The History Press
The Mill, Brimscombe Port
Stroud, Gloucestershire, GL5 2QG
www.thehistorypress.co.uk

British Library Cataloguing in Publication Data.
A catalogue record for this book is available from the British Library.

ISBN 978 0 7524 6529 6

Typesetting and origination by The History Press
Printed in Great Britain

CONTENTS

ACKNOWLEDGEMENTS

W
e would like to thank all those people who provided us with photographs for this book.

Thanks are also due to Tony Woolway, chief librarian at Media Wales, and his colleagues Edwina Turner and Rob Mager for their assistance. We also need to acknowledge Katrina Coopey and her staff at Cardiff Central Library Local Studies Department for their help over many years.

A special thank you to Richard Barrett for providing us with photographs from his late father Bill Barrett's collection. Bill was a well-known local historian and his 'My Cardiff' column in *The Cardiff Post* was enjoyed by thousands of Cardiffians. We would also like to thank those people who provided us with pictures that we were unable to use on this occasion. Finally, our thanks to all those at The History Press for assisting us with the production of this book.

INTRODUCTION

This book, a follow up to *Yesterday's Cardiff* first published in 2007, contains more than 200 fascinating pictures of a vanished city. In chapter one, City Centre Watering Holes, we visit a number of drinking dens and hotels in which our parents and grandparents might well have enjoyed a drink or two before the pubs were either knocked down or renamed. Some, like the historic Red Lion and Rose & Anchor in Kingsway, will still be remembered by Cardiffians of a certain age. In chapter two, Cardiff's Vanished Docklands, we pay a visit to the docks when sailing ships were in vogue and Captain Scott's ship the *Terra Nova* left Cardiff on its ill-fated journey to the South Pole in 1910. We also see the docks when it was a thriving coal port employing thousands of people. In chapter three, A Pub Crawl, we visit many of the pubs and hotels on the outskirts of the city, like the Cow & Snuffers in Llandaff which has now closed down and where local legend has it that Benjamin Disraeli once visited. We also enjoy a drink in the Canal Boat, now the Blackweir Tavern, and the Church Inn in Llanishen where Oliver Cromwell is said to have visited when he was in South Wales. In chapter four, Special Occasions, we join hundreds of Cardiffians in Cathays Park to welcome home the Cardiff City team which beat Arsenal 1-0 in the 1927 FA Cup. We join the thousands of people who attended the official opening of Roath Park in 1895, and from Fitzhamon Embankment we view the swimmers taking part in the once famous Taff Swim, held first in the River Taff and then later in Roath Park Lake. Chapter five, Movie Magic, sees us joining the queue outside the Cannon Cinema in Queen Street to see the Michael Jackson film *Moonwalker*. We also visit the Odeon to see *Crocodile Dundee* and *The Fly*, and the Monico, where the double bill is *Jurassic Park* and the ageless *Bambi*.

In chapter six, When Cardiff Went to the Dogs, we go greyhound racing at the 1928 Cardiff Royal Infirmary Benefit Night, held at the now long gone Welsh White City Stadium in Sloper Road. We also catch a glimpse of the legendary greyhound Mick the Miller. We welcome the royal family to Cardiff in chapter seven's Royal Visits, and Madam Toledo and fishmonger Tommy Letton are just two of the Cardiff characters we are introduced to in chapter eight, Local Shops & Stores. In this chapter we also go shopping in the Maypole, David Morgan Ltd, Evan Roberts and James Howell & Co. We also get to meet some of the Western Welsh Co. workers in the Cowbridge Road depot.

We go back to our grandparents', parents' and even our own schooldays in chapter nine, where we glance at the faces of the pupils of Gladstone, St Joseph's, Kitchener Road, Lady Margaret and other well-known Cardiff schools. We end our walk down Cardiff's memory lane with a look at some of the soccer and rugby teams that Cardiffians have supported over the years. We also get to meet Phil Edwards, the boxer who was dubbed 'the Marlon Brando of Wales' owing to his good looks, and former British heavyweight boxing champion Jack Petersen, admittedly long after he had hung up his boxing gloves.

1

CITY CENTRE
WATERING HOLES

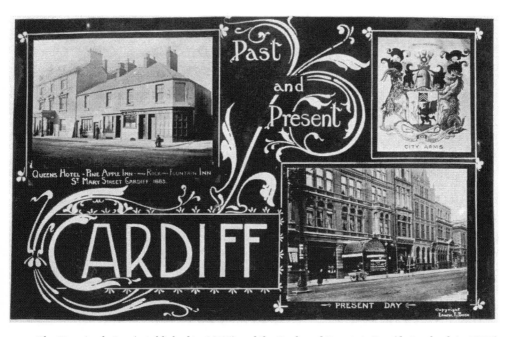

The Pine Apple Inn (established in 1855) and the Rock and Fountain Inn (dating back to 1875) in St Mary Street are now gone. (Ernest T. Bush)

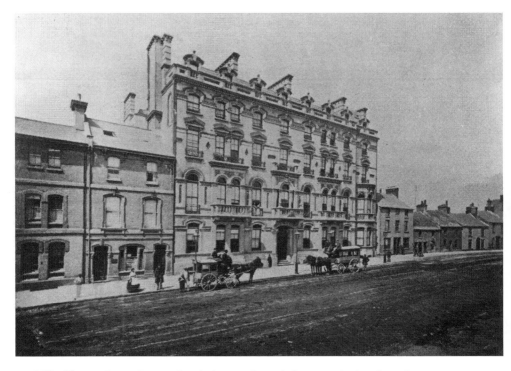

Cardiff's oldest and most historic hotel, the Royal Hotel, dates to 1866 and is still going strong even though it is not the size it once was. (Authors' collection)

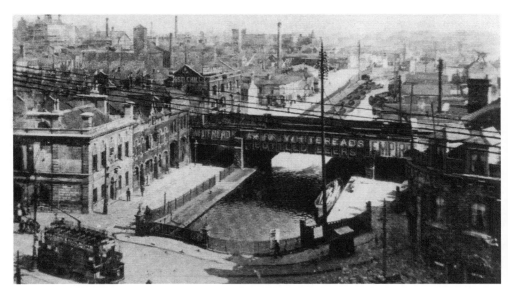

The Central Hotel, established in 1909 (right of picture), was destroyed in a fire and a new hotel called the Maldron now stands more or less on the same site. (Ernest T. Bush)

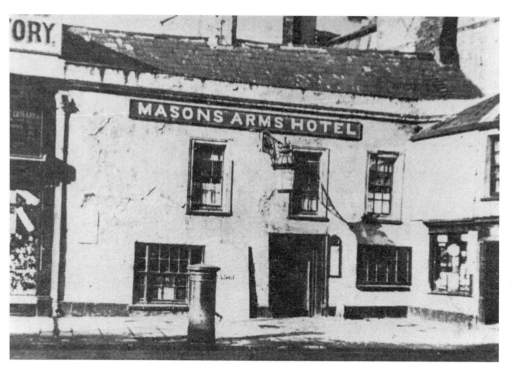

The post box outside the Masons Arms in Queen Street was believed to be the first post box in the town. The pub dated to 1792. (Ernest T. Bush)

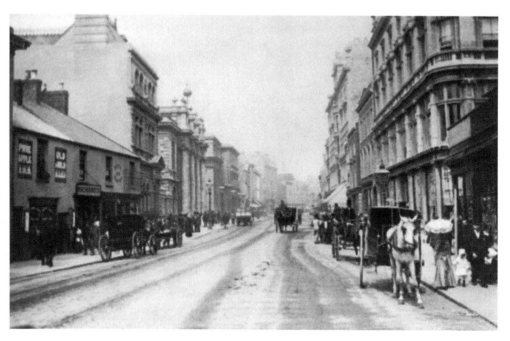

The Pine Apple Inn in St Mary Street is the first building on the left of the picture. (Authors' collection)

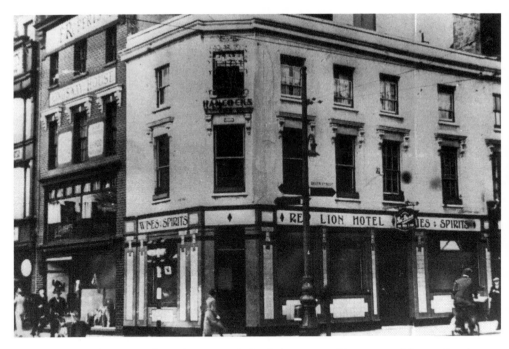

The Red Lion on the corner of Smith Street and North Street, now Kingsway and Queen Street, was established in 1792. It was still serving pints in the 1950s. (Media Wales)

The Rose & Crown on Kingsway (left of picture), established in 1787, was demolished in 1974 despite a campaign to save it. (Authors' collection)

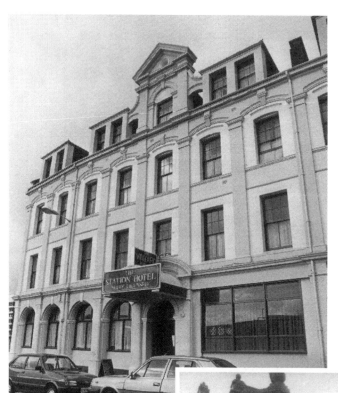

The Station Hotel on Station Terrace, *c.* 1988. Once a retreat for servicemen, it was previously known as the Railway Hotel and Brownhills. (Media Wales)

The Queens Hotel in St Mary Street, which became the Irish Bank upon closing. (Media Wales)

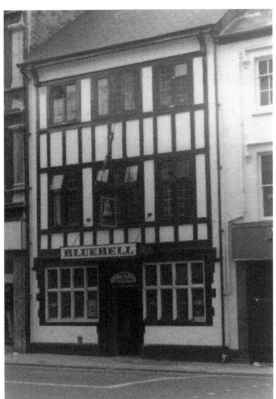

The Bluebell in the High Street is now known as the Goat Major and dates back to 1813. (Mike Street)

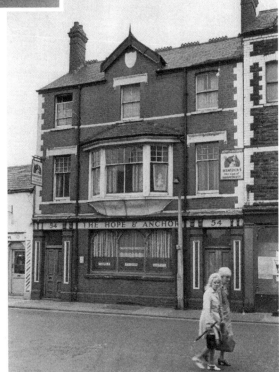

The Hope & Anchor, which used to be in Bridge Street, dated back to 1897 and is seen here in 1971. (Media Wales)

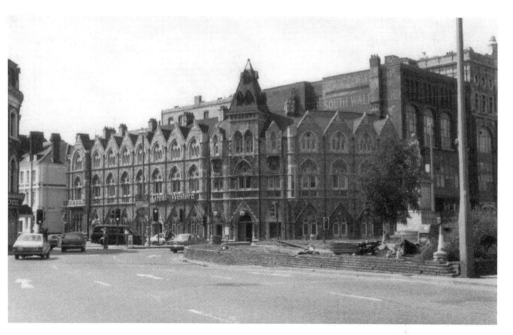

The Great Western Hotel, *c.* 1980. Also dated to 1897, the hotel has had several different names over the years but it has now reverted to its original name. (Harmer Paterson)

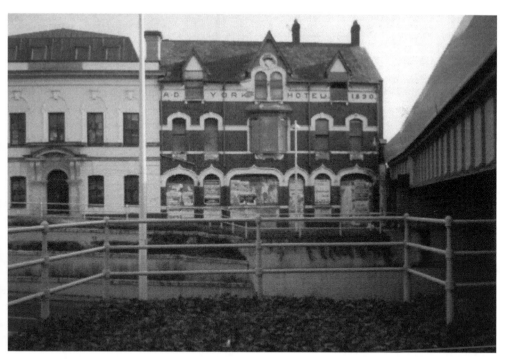

Boatmen using the the long-gone Glamorganshire Canal would have been familiar with the York Hotel, first licensed in 1875. The building in this picture was opened in 1890. (Authors' collection)

The Terminus (left of picture) was originally known as the Steam Mill Arms. During the 1990s, it was known as Sam's Bar, and was renamed Zync in 2005. It is now known as Peppermint Bar. It was established in 1875. (Authors' collection)

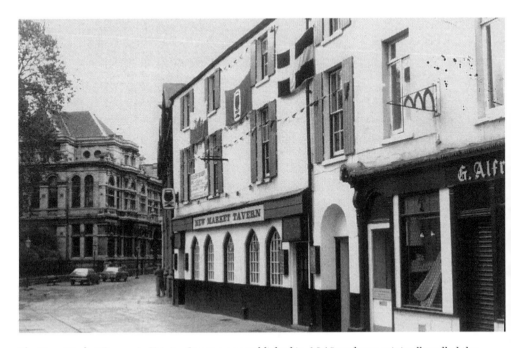

The New Market Tavern in Trinity Street was established in 1840 and was originally called the New Market Inn. It had an opening that led to Church Street and is now known as O'Neill's. (Mike Street)

Right The Cambrian Hotel on the corner of St Mary Street and Caroline Street was built in 1830 and rebuilt in 1889. It was known as Mulligans during the 1990s and is now known as Kitty Flynn's. (Harmer Paterson)

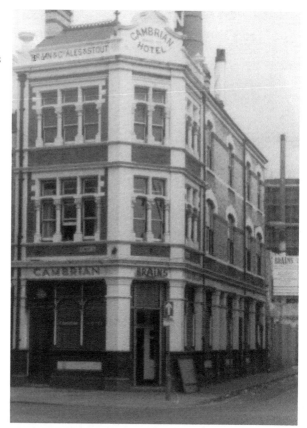

Below The Lifeboat Tavern, established in 1897, was formerly the Lifeboat Inn and stood on the corner of Little Frederick Street and David Street. It was demolished in 1978 and a multi-storey car park was built on its site. (Mike Street)

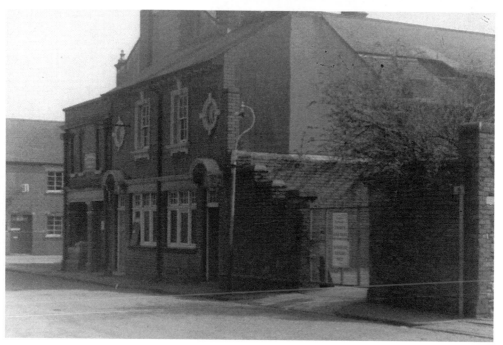

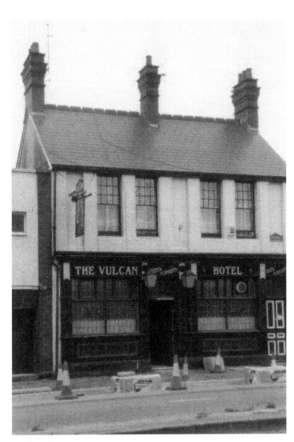

Left Despite a campaign to save it, one of Cardiff's oldest pubs, The Vulcan, was due for demolition in 2012. Mr D. Howells was the landlord in 1875. (Mike O'Sullivan)

Below The Tivoli Hotel in Queen Street, established in 1909, stood almost opposite the Principality Building Society, left of picture. (Authors' collection)

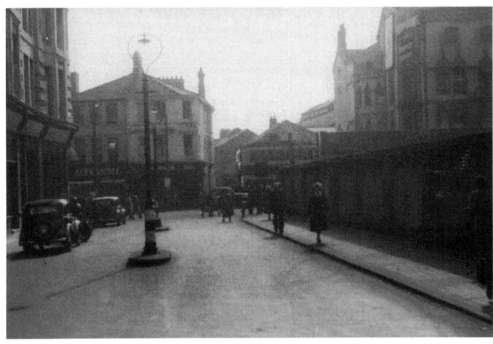

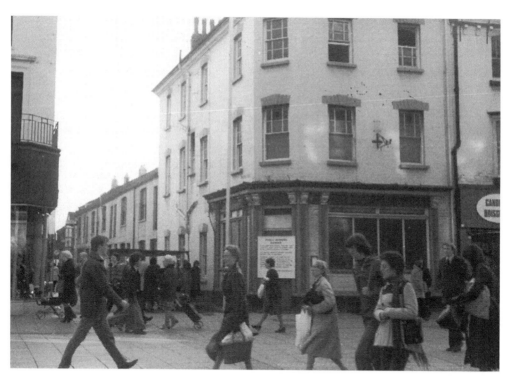

The Taff Vale Inn, established in 1875, was situated on the corner of Paradise Place and Queen Street. It was closed when this picture was taken, just before it was demolished in 1978. (Authors' collection)

The Central Hotel, which was destroyed in a fire. It was known at one time as Hotel Diplomat. (Authors' collection)

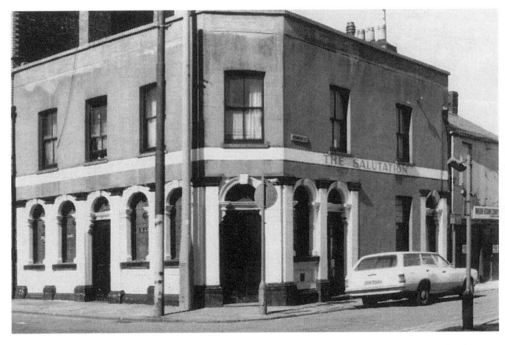

The Salutation in Hayes Bridge Road was established in 1847 and closed in 1982. (Tony Blood)

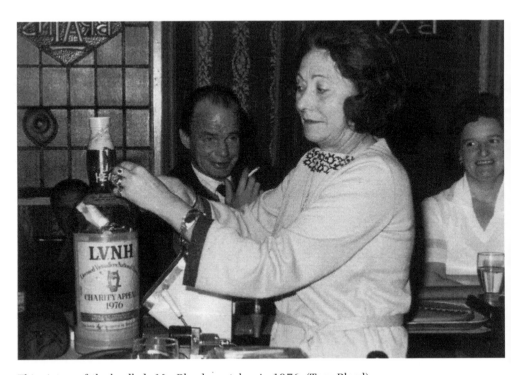

This picture of the landlady Mrs Blood was taken in 1976. (Tony Blood)

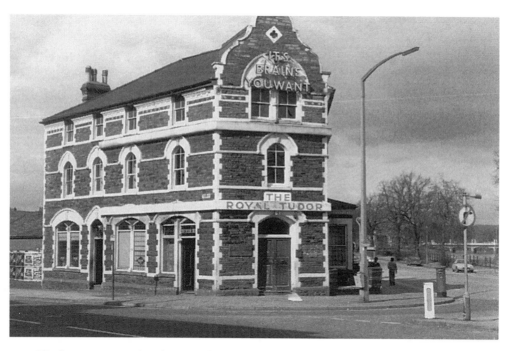

The long-gone Royal Tudor in Tudor Street. To the right of the picture can be seen Cardiff Bridge, known to most Cardiffians as Canton Bridge. (Mike O'Sullivan)

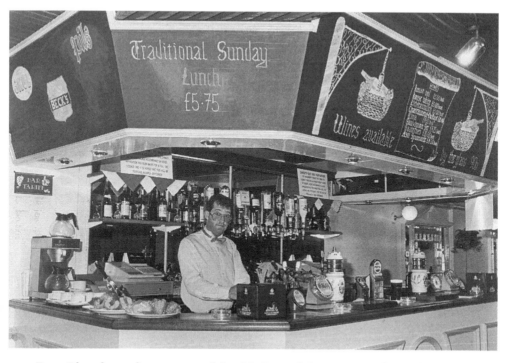

Terry Edwards was bar manager of Sandy's Bar and Restaurant in the Sandringham Hotel during the 1990s. (Media Wales)

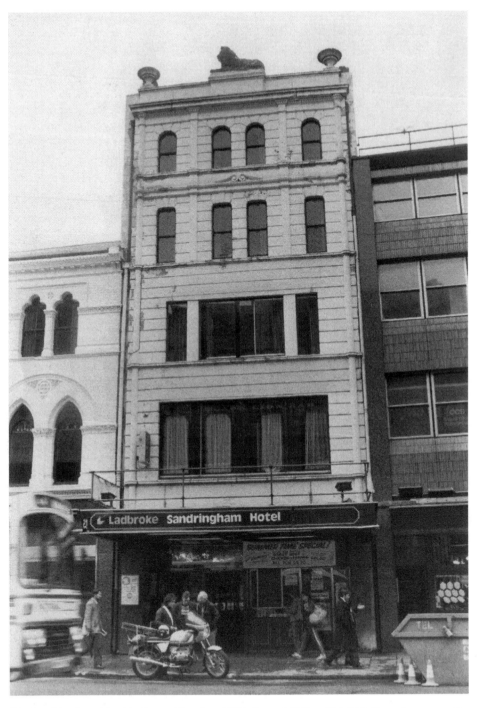

The Sandringham Hotel in Queen Street, *c.* 1984. From 1792 until 1906, it was known as the Black Lion. See the lion on top of the building. (Media Wales)

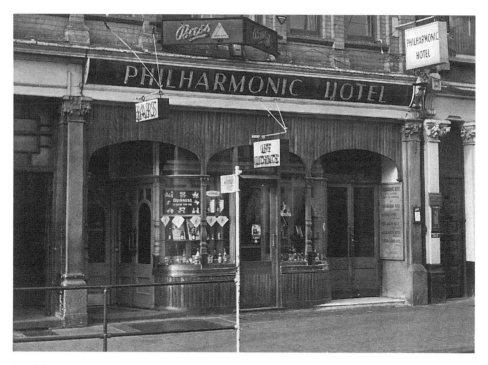

The Philharmonic Hotel in St Mary Street, established in 1912, is seen here in 1962. (Media Wales)

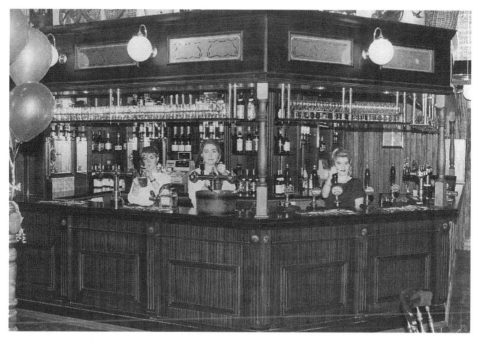

Barmaids pictured in the newly designed bar at the re-opening of the Philharmonic Hotel in 1990. (Media Wales)

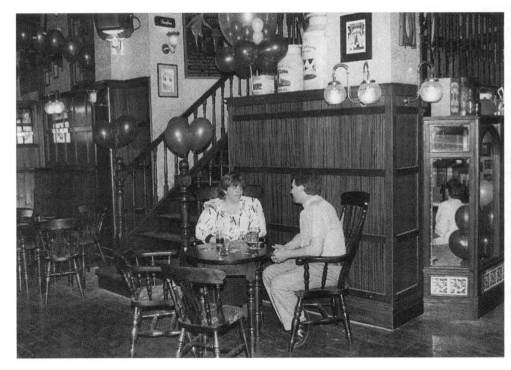

This couple are pictured in a section of the newly designed bar seating area at the Philharmonic Hotel in 1990. (Media Wales)

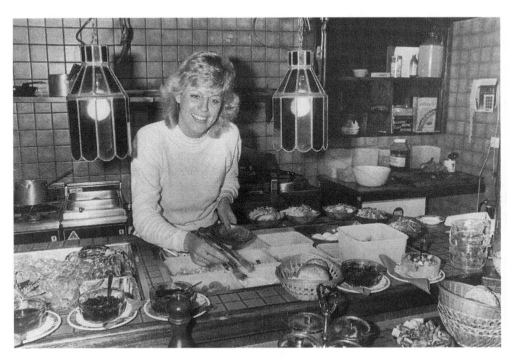

Lisa Cullen prepares a salad in the Philharmonic Hotel restaurant, *c.* 1988. (Media Wales)

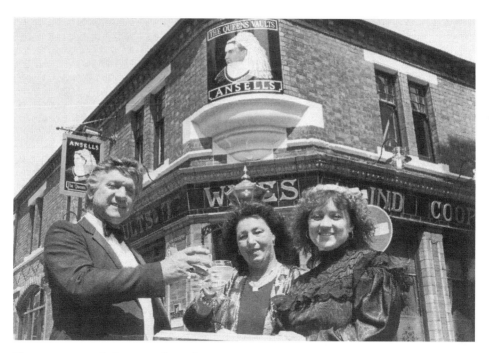

The re-opening of the Queen's Vaults in Westgate Street, *c.* 1990. The landlord Mr Frank Milton and his wife Shirley are seen here with their daughter, Mrs Karen May (right), dressed in Victorian costume. (Media Wales)

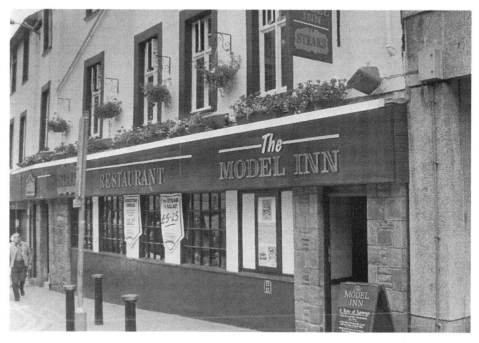

The Model Inn in Quay Street, *c.* 1990. Once known as the Ship on Launch, it dates to 1855. It is now known as Greenwood & Brown. (Media Wales)

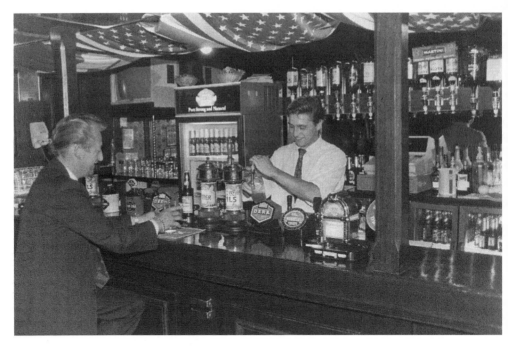

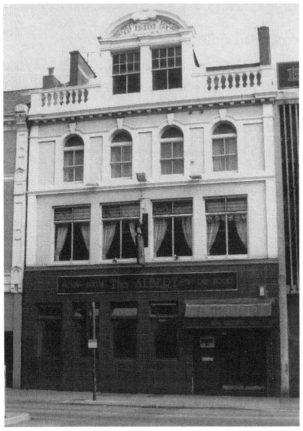

Above Pictured in the upstairs bar of the Model Inn is assistant manager Jason Clifford, who is serving a customer in 1990. (Media Wales)

Left The Albert in St Mary Street, which dated to 1875, is now part of The Yard. (Mike O'Sullivan)

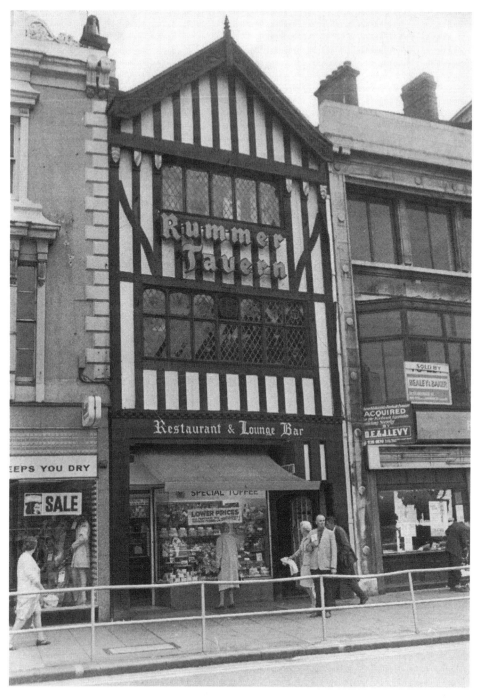

The Rummer Tavern in Duke Street, pictured in 1971, was established in 1813. Known as one of the most famous ports of call in South Wales, passengers would dash in and down their hot grog as soon as the coach arrived. (Media Wales)

Above The historic Golden Cross in Custom House Street still stands, but the Fishguard Arms (seen to the right of the building) has been demolished. The Golden Cross has had several different names since it was established in 1855. This picture was taken in 1984. (Mike O'Sullivan)

Left The Cottage in St Mary Street used to be known as the Cardiff Cottage and dates to 1858. (Mike Street)

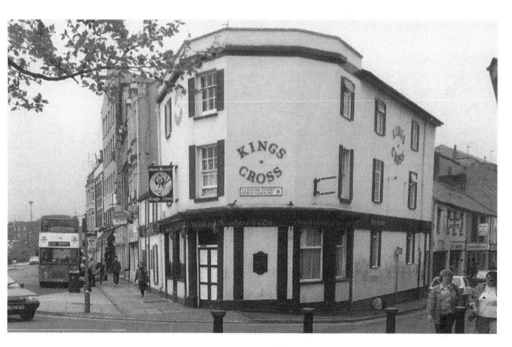

The Kings Cross on the corner of Mill Lane and Caroline Street dated to around 1882 and was known for its gay atmosphere until it became the Corner House, or Y Ty Cornel, in 2011. Mine host in 1901 was George Meyrick John. (Authors' collection)

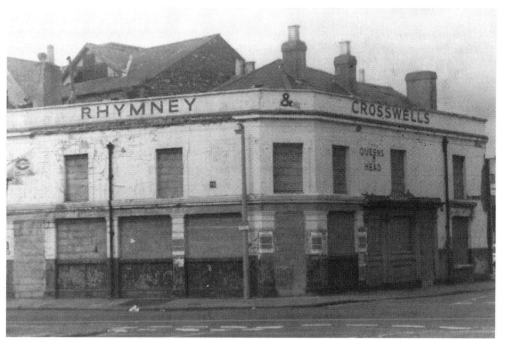

The Queens Head, which used to be in Bridge Street, dated to 1858 and had already closed when this picture was taken. (Mike O'Sullivan)

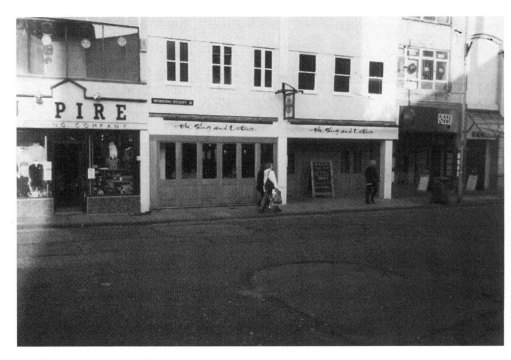

The Slug and Lettuce in Working Street had a very short life. It is now the Cheltenham and Gloucestershire Building Society. (Authors' collection)

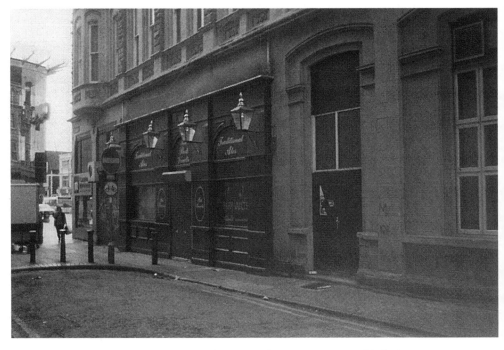

The Park Lane Bar on the corner of Park Lane and Queen Street, established in 1887, was known as the Park Vaults. It is now a Ladbrokes betting shop. (Authors' collection)

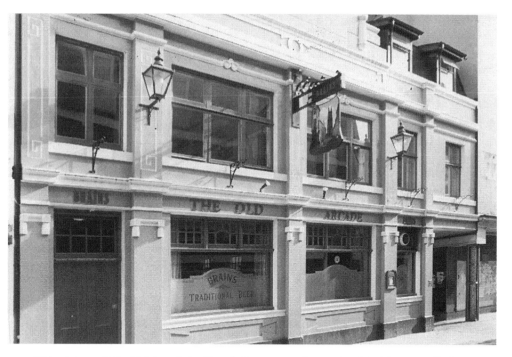

This picture of The Old Arcade in Church Street was taken in April 1984. Originally known as the Arcade & Post Office Inn, it dates to 1858. (Harmer Paterson)

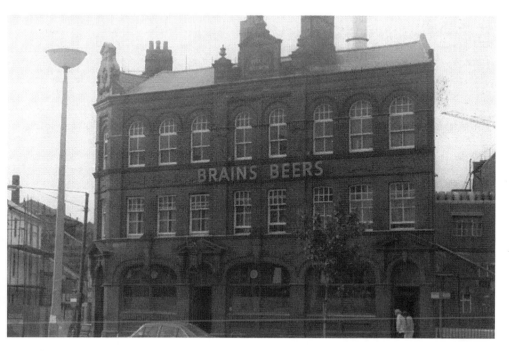

The Duke of Wellington is situated on the corner of Caroline Street and The Hayes and dates to 1901, when a Mr Griffiths was the landlord. (Mike Street)

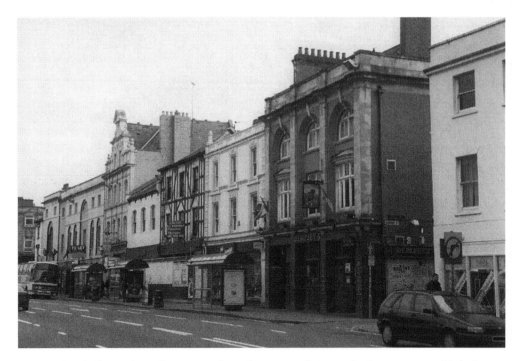

Dempsey's, which stands on the corner of Castle Street and Womanby Street, was established in 1731 and has been known as The Globe, Duke's and Four Bars Inn. This picture was taken in 2002. (Harmer Paterson)

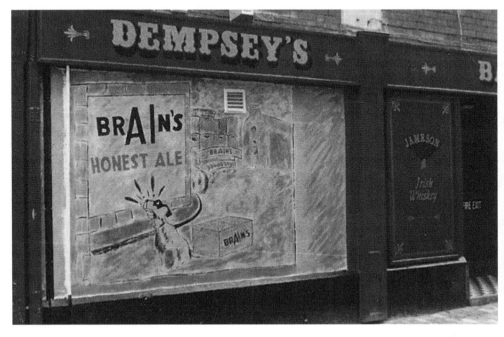

The side entrance to Dempsey's in Womanby Street, showing an advertisement for Brain's Honest Ale. (Harmer Paterson)

The Marchioness of Bute in Frederick Street, established around 1846, closed sometime in the 1960s. (Harmer Paterson)

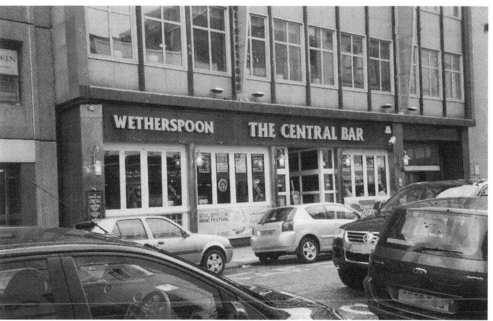

The Wetherspoon Central Bar in Windsor Place was built on the site of an old chapel, which was later converted to a synagogue. (Authors' collection)

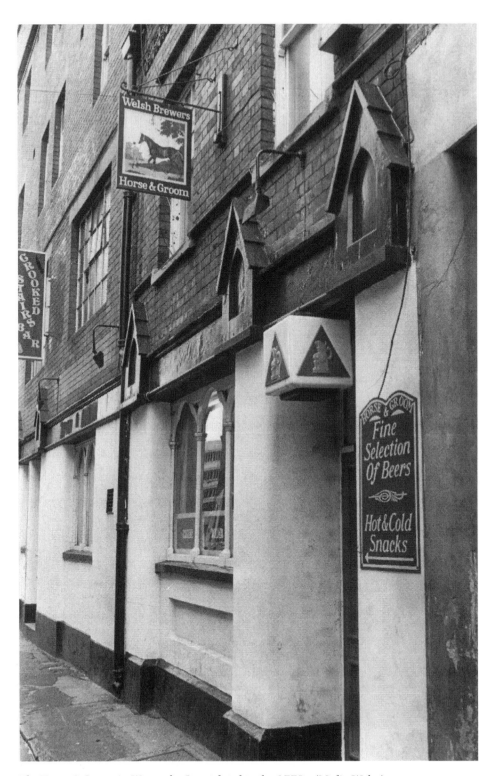

The Horse & Groom in Womanby Street dated to the 1770s. (Media Wales)

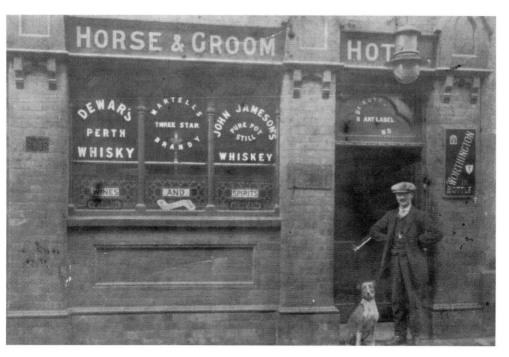

Fred Nelmes was the landlord of the Horse & Groom during the First World War and he is seen here with his lurcher dog. His daughter Evelyn took the picture. (Marjorie Young)

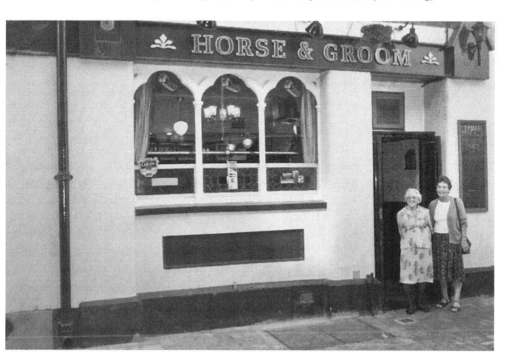

This picture shows Evelyn Young, *née* Nelmes, with her daughter-in-law Marjorie Young, outside the pub in 1996. (Marjorie Young)

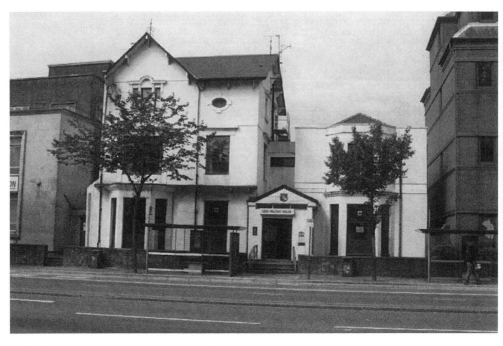

Odd Fellows House in Newport Road. (Colin Duggan)

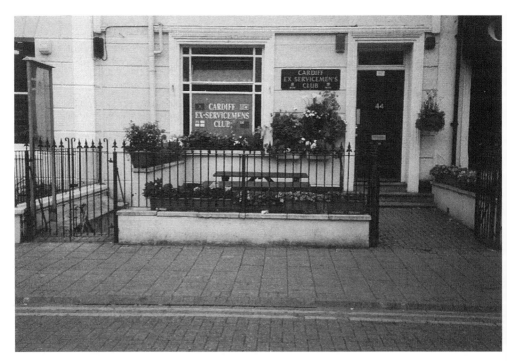

The Cardiff Ex-Servicemen's Club in Charles Street. Crete war veterans held their monthly meetings here for twenty years. This picture was taken in 2002. (Colin Duggan)

Johnny Walsh, mine host of the Criterion in Church Street, says goodbye to his wife before setting out on a pub outing in the 1950s. (Authors' collection)

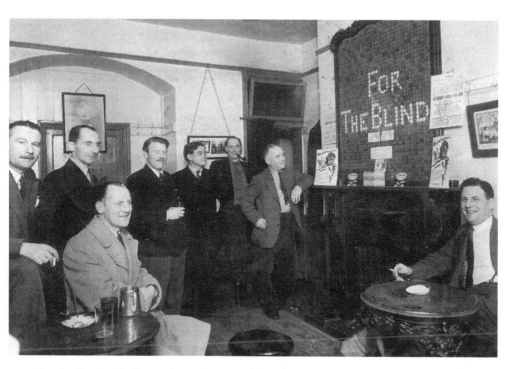

Pennies for the Blind! Mine host Johnny Walsh with his elbow on the mantelpiece, surrounded by some of the Criterion's regular customers. (Authors' collection)

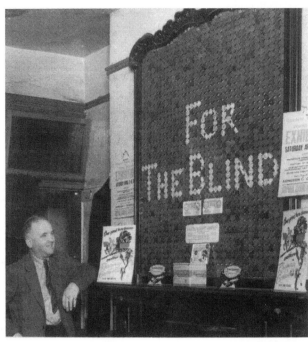

Left Johnny Walsh gazes up at the number of coins above the mantelpiece. The Criterion dated back to 1897. (Authors' collection)

Below A rare picture of the now long-gone Bristol Hotel. (Mike Street)

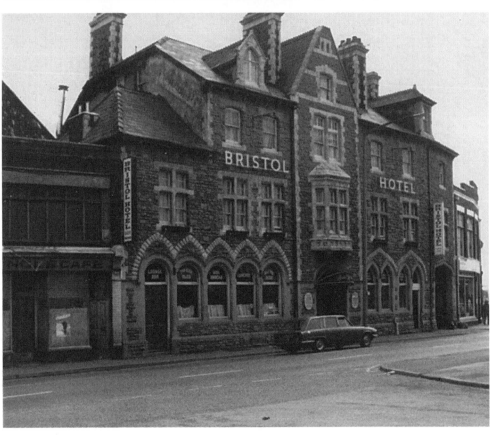

2

CARDIFF'S VANISHED DOCKLANDS

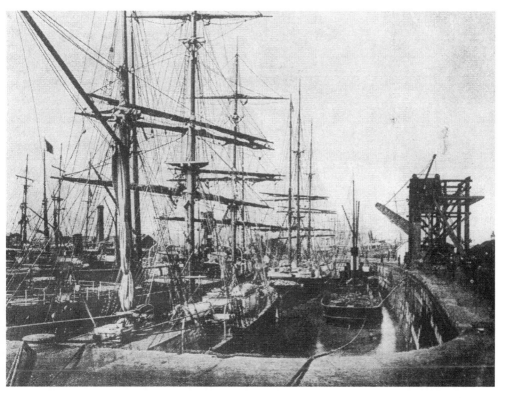

When sailing ships ruled the waves: a packed East Dock during the port's heyday. (Authors' collection)

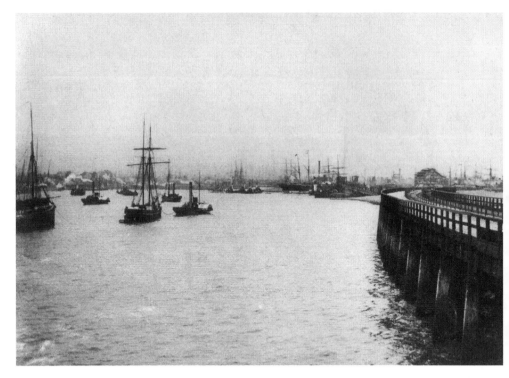

A close up of the low water pier which was opened by the Marquess of Bute for passengers to America and other far-flung countries. (Authors' collection)

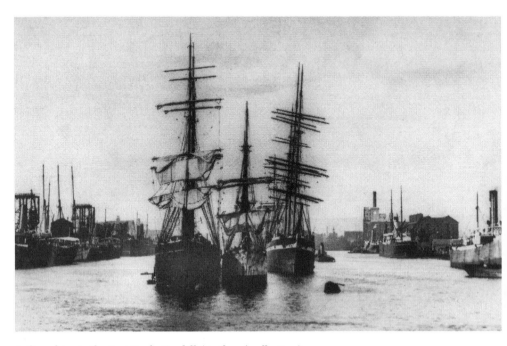

Sailing ships in the East Dock, Cardiff. (Authors' collection)

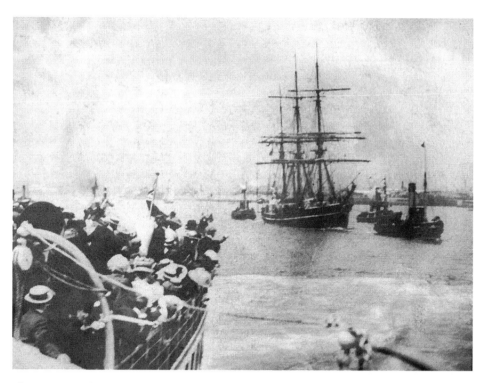

The *Terra Nova* leaves Cardiff with Captain Scott's expedition party for the South Pole. This picture was taken in 1910. (Authors' collection)

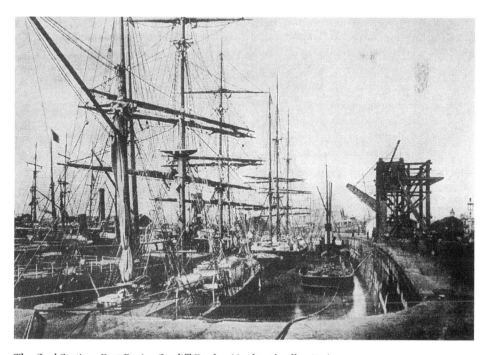

The Coal Station, East Basin, Cardiff Docks. (Authors' collection)

Splice the mainbrace!
This picture was taken by
W. Morgan Davies of Cardiff.
(Authors' collection)

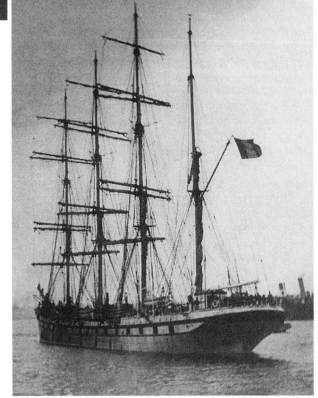

A sailing ship sails into Cardiff
Docks. (Authors' collection)

The *Lizzie*, a Cardiff ship, in the graving dock for repairs. (Authors' collection)

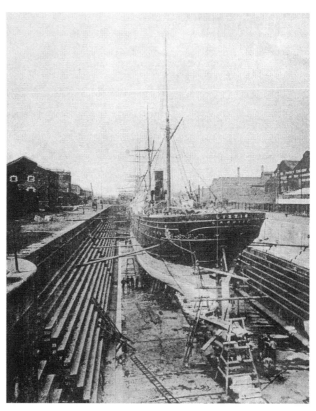

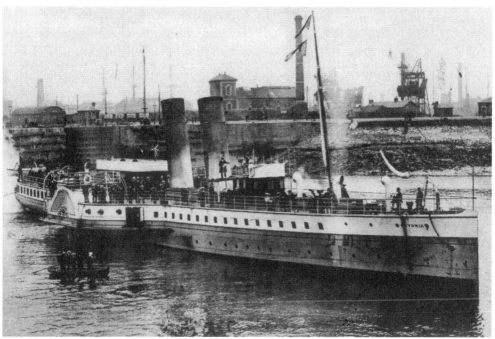

The SS *Devonia* steamship in Cardiff Docks. (Authors' collection)

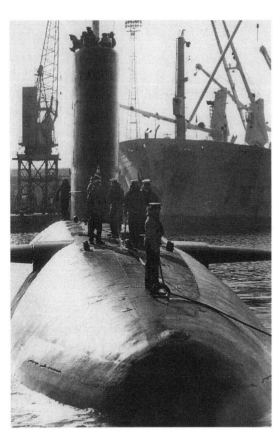

Left The nuclear submarine HMS *Valiant* visited Cardiff Docks in 1977. (Associated British Ports)

Below Cambrian in Cardiff Docks. (John Smith)

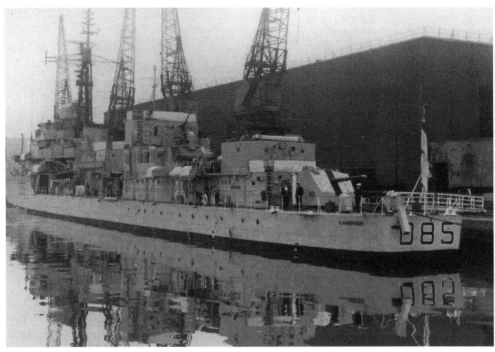

Right A 60-ton floating
crane in Cardiff Docks during
the Second World War.
(Associated British Ports)

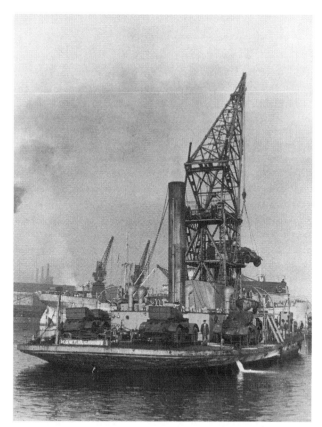

Below A spitfire being loaded
onto one of the Empire ships
at Roath Dock, Cardiff, during
the Second World War.
(Authors' collection)

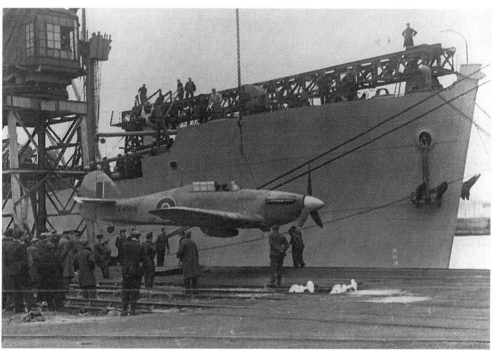

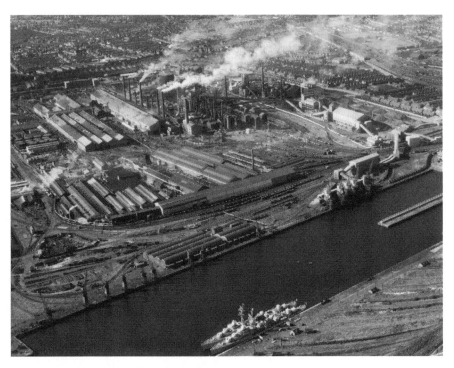

During the 1960s, Cardiff Docks was still a hive of industry. (Terence Soames (Cardiff) Ltd)

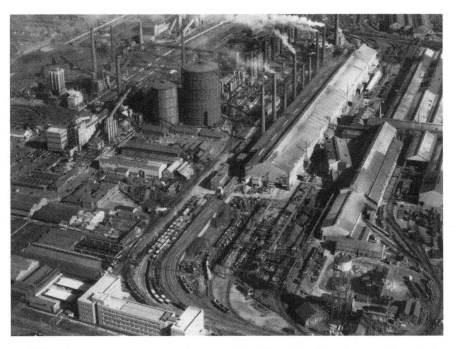

Cardiff Docks is now just a memory, but many Cardiffians found employment there in the 1950s and 1960s. (Terence Soames (Cardiff) Ltd)

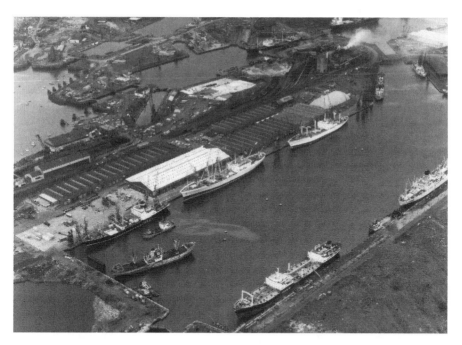

The Queen Alexandra Dock in 1972. It was opened in July 1907 by King Edward VII. (Terence Soames (Cardiff) Ltd)

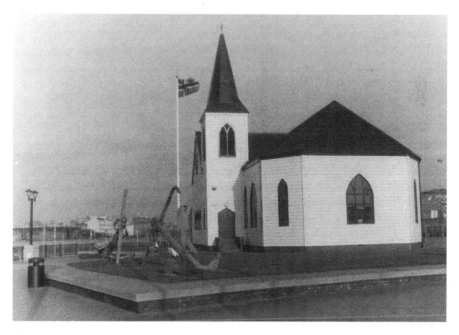

The original Norwegian Seamen's Mission Church stood on the eastern side of the West Bute Dock from 1866 to 1959. It was replaced by this white-painted traditional wooden replica. (Gerald May)

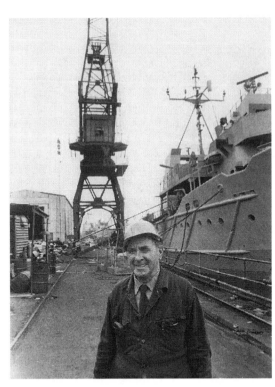

Crane driver Bill O'Neill standing near his crane at the Commercial Dry Dock, *c.* 1960. The ship in port is the HMS *Venturer*. (John Smith)

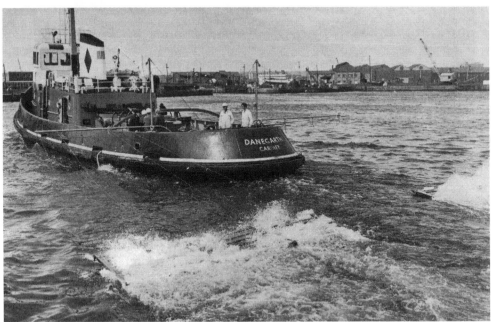

The *Danegarth* was one of Cardiff Docks' well-known tugs and is seen here during an anti-pollution exercise at Roath Dock in 1970. The spraying tubes can be seen in the water. (Authors' collection)

3

A PUB CRAWL

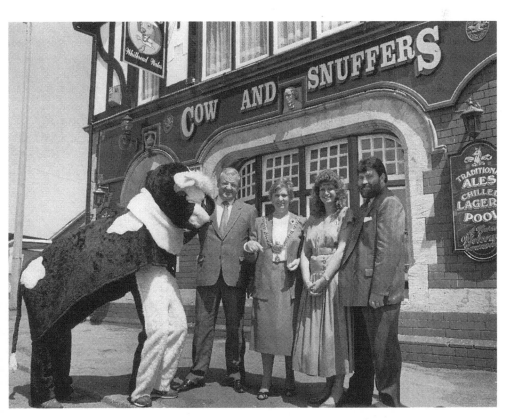

The Lord Mayor of Cardiff, Councillor Beti Jones, officially reopened the Cow & Snuffers inn in Llandaff in 1989 with the help of a pantomime cow. Sadly, the pub closed its doors for good in 2011. Pictured left to right are Whitbread's Allan Owen, Lord Mayor Councillor Beti Jones, and licensees Cindy and Garth White. (Media Wales)

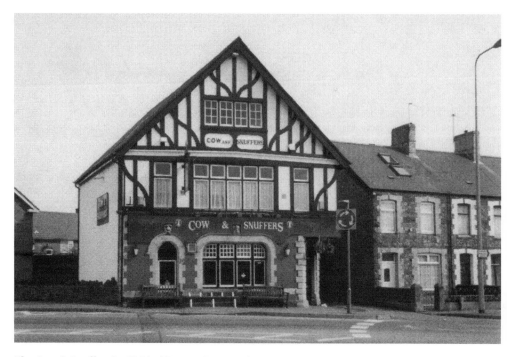

The Cow & Snuffers in 2001. (Harmer Paterson)

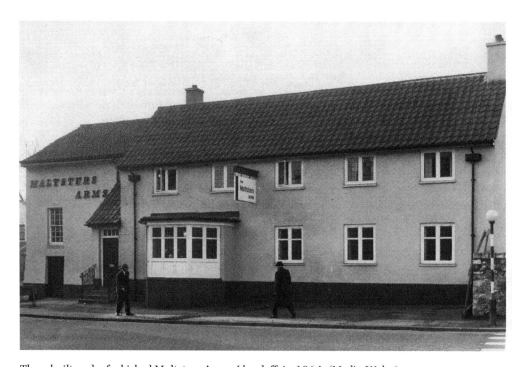

The rebuilt and refurbished Maltsters Arms, Llandaff, in 1964. (Media Wales)

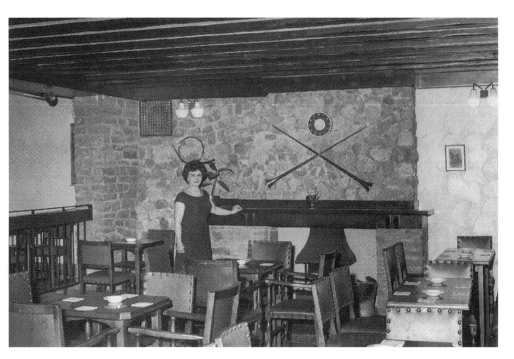

Interior view of the rebuilt and refurbished public bar at the Maltsters Arms, Llandaff, in 1964. (Media Wales)

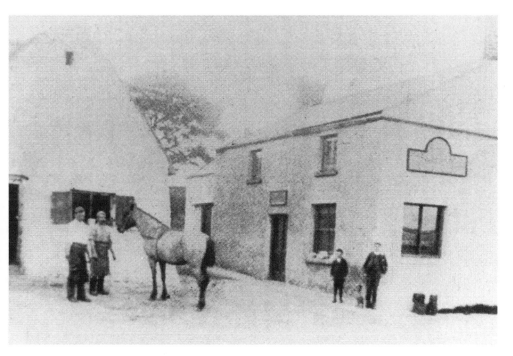

The Dusty Forge Inn in Cowbridge Road West, Ely, dated from 1790. When it closed, it became a community centre. (Authors' collection)

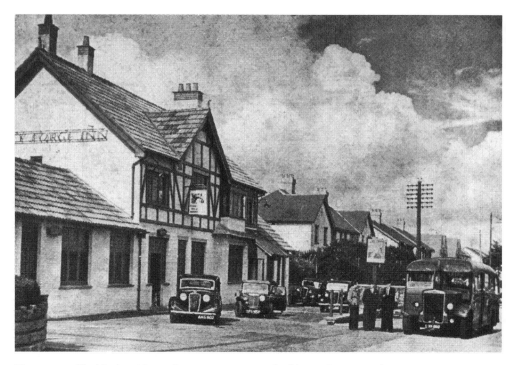

There was still a blacksmith on the site in a separate building adjacent to the Dusty Forge Inn for many years. (Authors' collection)

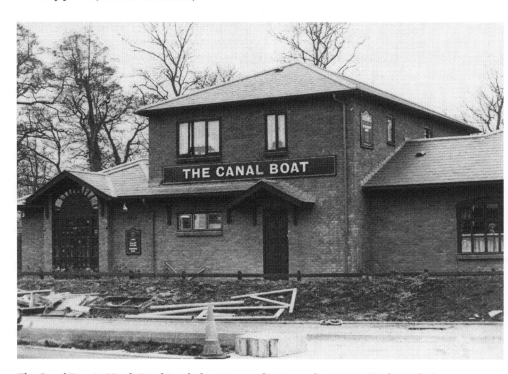

The Canal Boat in North Road just before it opened in December 1988. (Media Wales)

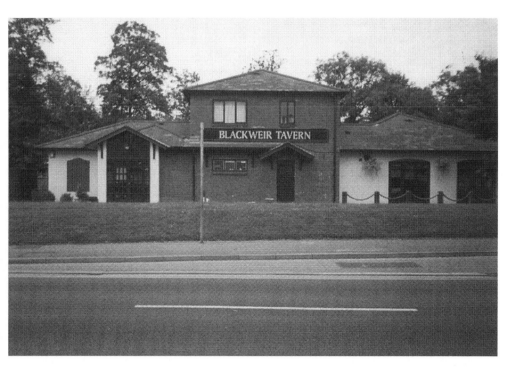

The Canal Boat, which was situated near to where the Glamorganshire Canal used to run, was later renamed the Blackweir Tavern. (Authors' collection)

The Inn on the Avenue is another hotel which has been renamed, and is now known as the Park Inn. (Media Wales)

A different view of the Inn on the Avenue, which is around three miles from the centre of Cardiff and just off the Llanedeyrn roundabout. (Media Wales)

The 150-bedroom Cardiff Post House in Pentwyn was opened in July 1972. Mr Gerry McGee, general manager, is pictured standing outside the hotel. (Media Wales)

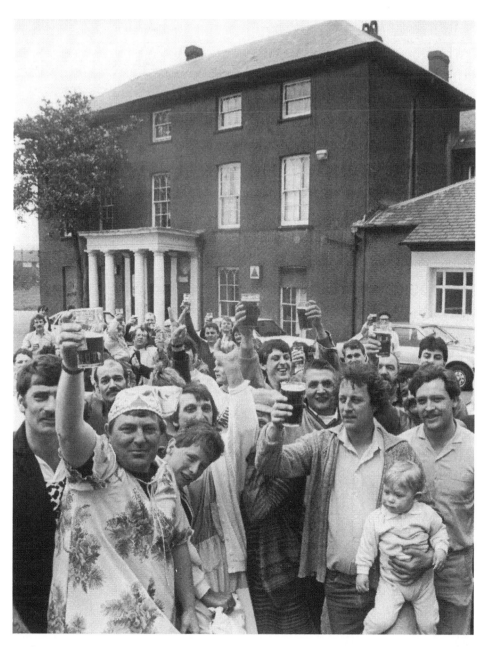

In the 1980s, regulars of the historic Llanrumney Hall Hotel in Llanrumney mounted a five-day campaign to oust the landlord, and as can be seen in the picture, they were successful. (Media Wales)

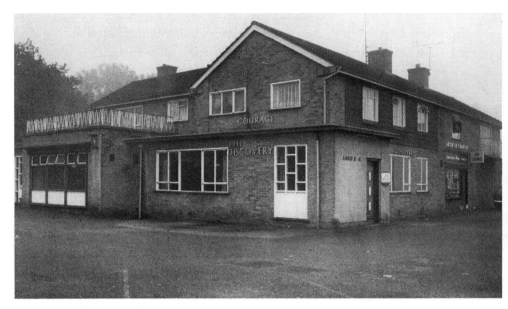

The Discovery, which is named after one of Captain Scott's ships, is situated at the junction of Celyn Avenue and Clearwater Way. This picture was taken in 1975. (Media Wales)

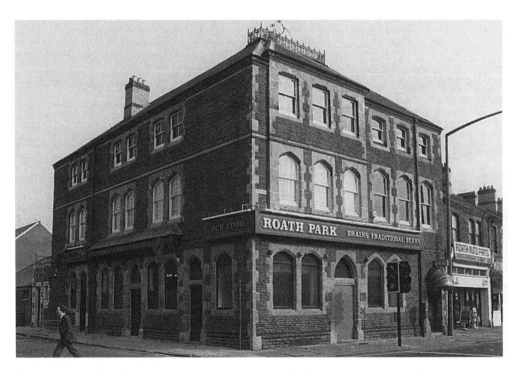

The Roath Park hotel in City Road was completely refurbished and modernised in 1985. Blown-up photographs of the City Road area at the turn of the century decorated the walls, giving patrons a glimpse of life in the area at that time. (Media Wales)

Right The skittle alley in the Roath Park hotel was a feature of this popular pub and at the time this picture was taken in 1985, the new licensees were Lindsay and Sandra Davies. (Media Wales)

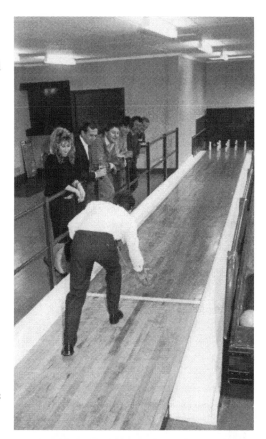

Below This is how the lounge of The Good Companions in Llanrumney looked when the pub was opened in 1958. This is another pub that has now vanished from the streets of Cardiff. (Media Wales)

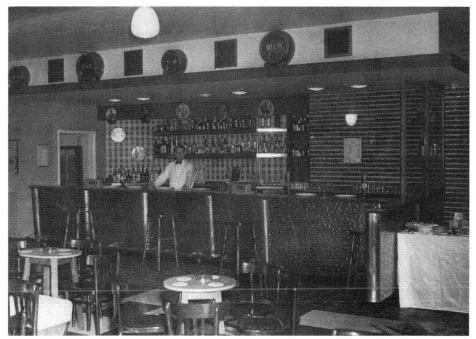

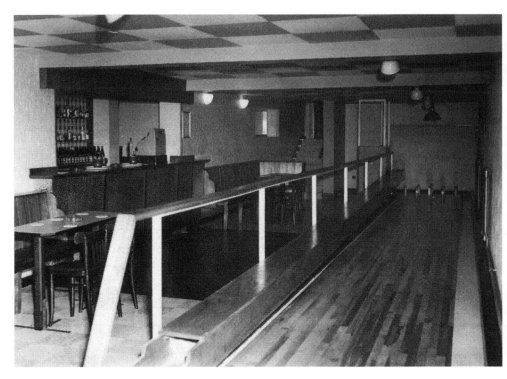

The Good Companions was built by the brewers Mitchells and Butlers. This picture shows the skittle alley which was part of the Sportsman's Bar. (Media Wales)

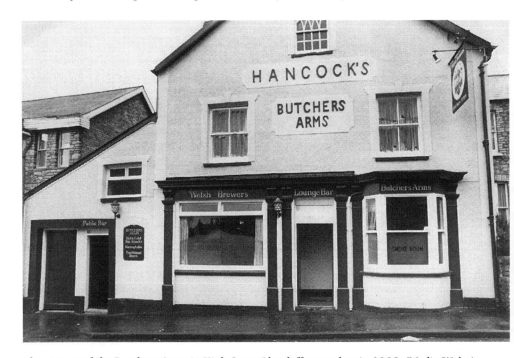

This picture of the Butchers Arms in High Street Llandaff was taken in 1982. (Media Wales)

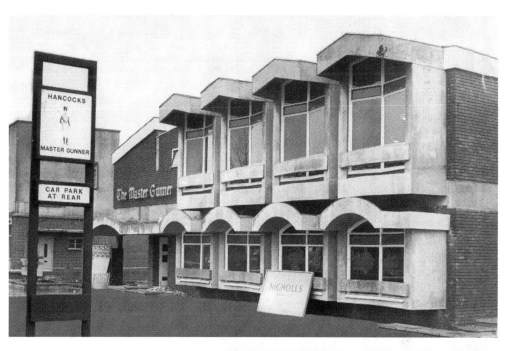

Above The Master Gunner in Gabalfa had just opened when this picture was taken in 1966. (Media Wales)

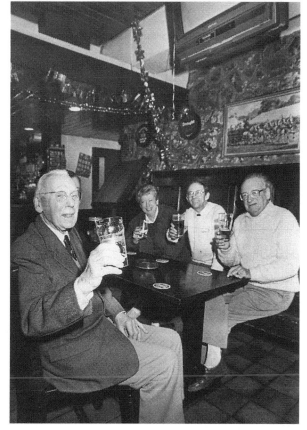

Right Seen in the Deri Inn's Village Bar in Rhiwbina is Edgar Jenkins (far left) at eighty-seven, who was the pub's oldest regular and witnessed its conversion from a farm house. Pictured far right is Len Davis from Rhiwbina. (Media Wales)

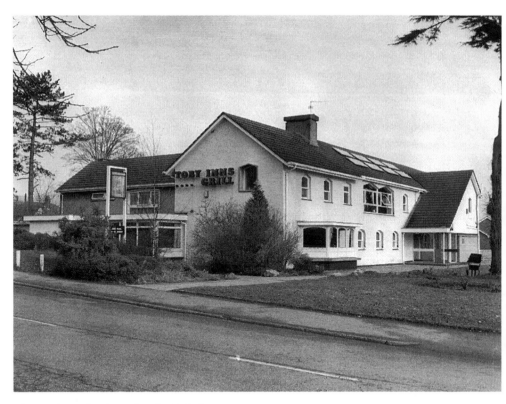

The Deri Inn, Rhiwbina. (Media Wales)

The Pennsylvania public house in Llanedeyrn pictured in the April of 1971. (Media Wales)

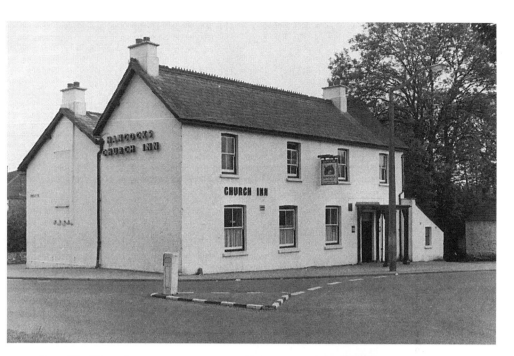

Above The fifteenth-century Church Inn in the village of Llanishen in 1972. Local legend has it that Oliver Cromwell stayed there when he visited South Wales. (Media Wales)

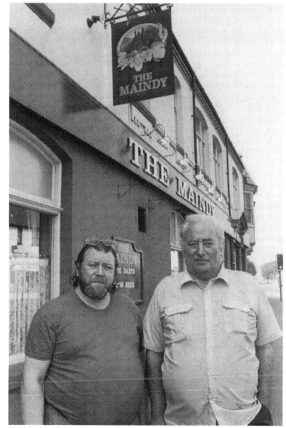

Right Two regulars of the Maindy hotel in North Road were John Bester (left) and Richard Harvey, pictured in 1986. (Media Wales)

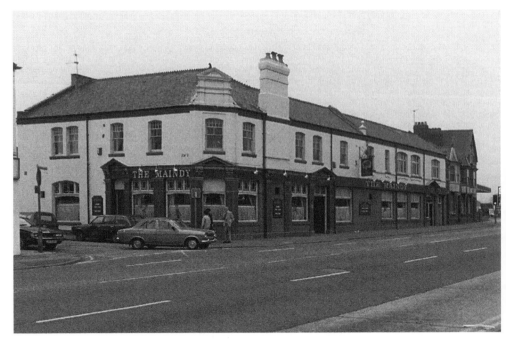

The Maindy hotel, *c.* 1988 – another Cardiff pub which has closed its doors. (Media Wales)

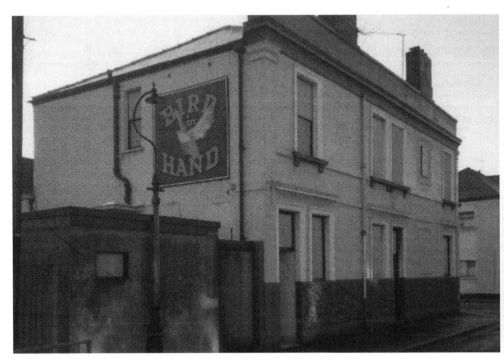

The Bird in Hand at 1 Hewell Street, Grangetown, was closed when this picture was taken in June 1995. (Harmer Paterson)

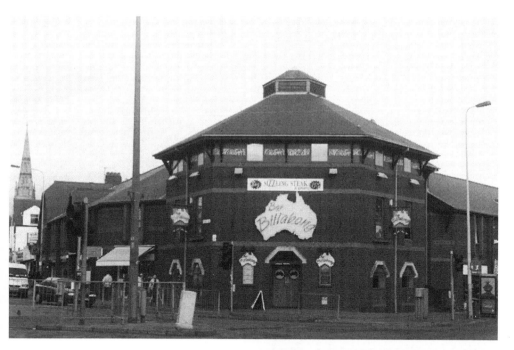

Above The Billabong on the corner of Wellfield Road and Albany Road was built on the site of the old Globe Cinema. (Authors' collection)

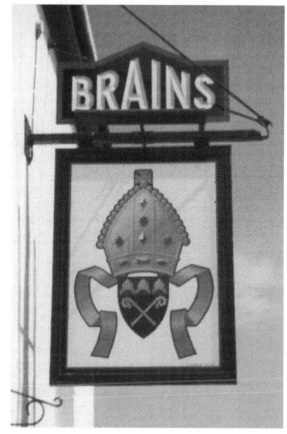

Right A Brains pub sign for The Mitre in Wyndham Street, Canton. (David Matthews)

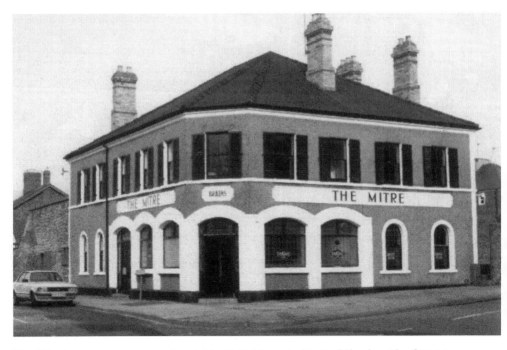

The Mitre in Grangetown, according to David Matthews in his Cardiff pub guide of 1995, was 'A friendly darts locals' pub, with an excellent landlord'. It also had 'a swearing parrot called Charlie'. (David Matthews)

The Red Cow in Wellington Street, Canton; not to be confused with the Red Cow that used to be in Womanby Street. (Authors' collection)

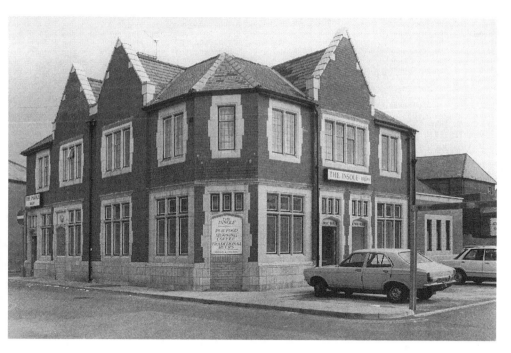

Another Canton pub was The Insole, which served morning coffee and traditional beers. It is mentioned in Howard Spring's novel *Heaven Lies About Us: A Fragment of Infancy*. This picture was taken in 1983. (Media Wales)

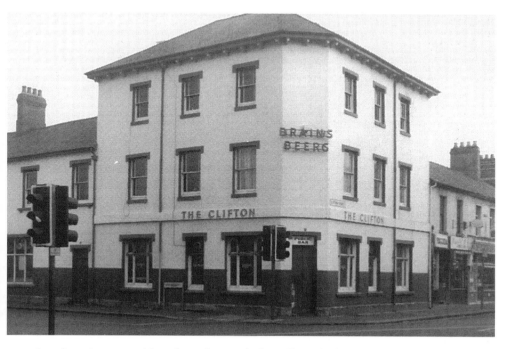

A poltergeist was said to have haunted the cellar of The Clifton hotel in Broadway. (Mike O'Sullivan)

The Grosvenor in Moorland Road, Splott, was popular with steel workers in days long gone. (Media Wales)

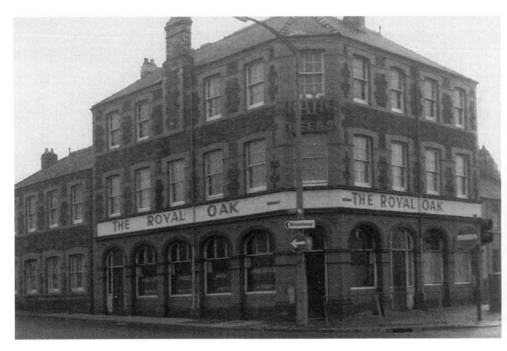

The Royal Oak in Broadway. Peerless Jim Driscoll, the Cardiff boxer, used to train in the upstairs gymnasium. (Mike O'Sullivan)

The Inn on the River at 76 Taff Embankment, Grangetown, was up for sale when this picture was taken. It had a pool table and satellite television, and bands often played there. (Authors' collection)

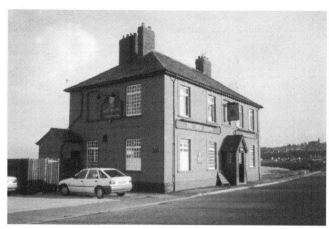

The Red House in Ferry Road, which has now been demolished. It was also known as the Railway Hotel, and later the Penarth Railway Hotel. This picture was taken in the January of 1995. (Authors' collection)

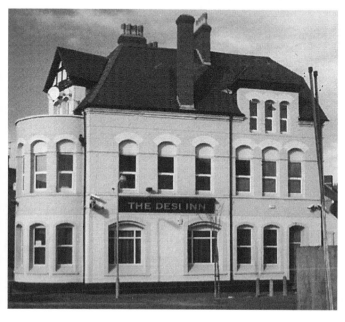

The Desi Inn in Grangetown. (Authors' collection)

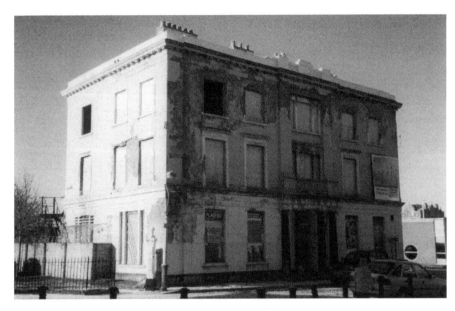

The famed Big Windsor in Cardiff's docklands was waiting for refurbishment when this picture was taken in 2001. It is now an Indian restaurant. (Harmer Paterson)

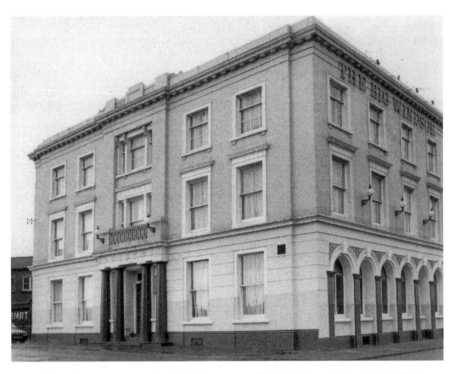

This is how the Big Windsor looked after it was refurbished. Established in 1855, it was well known for its gastronomic delights, and Noel Coward, Henry Williamson, Katharine Hepburn, Kenneth More, Gwyn Thomas, Daniel Farson and Hugh Griffith are just some of the famous people who dined there. (Mike Street)

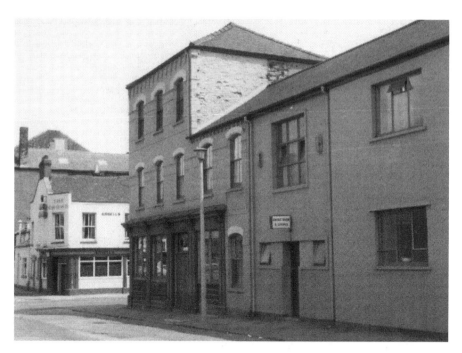

The year is 1980. The Crown pub is to the left of the picture, and the Custom House in Bute Street is on the right. The Custom House, which was a regular haunt of ladies of the night, was opened in around 1859 and was demolished in the 1990s. (Harmer Patersen)

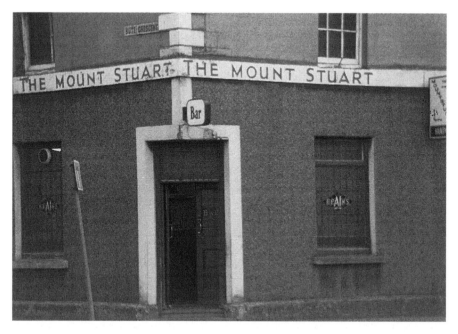

The Mount Stuart was in Bute Crescent in Cardiff's docklands and it was the first port of call for seamen and dockers. Established around 1889, it had fourteen bedrooms and stabling for nine horses. (Gerald May)

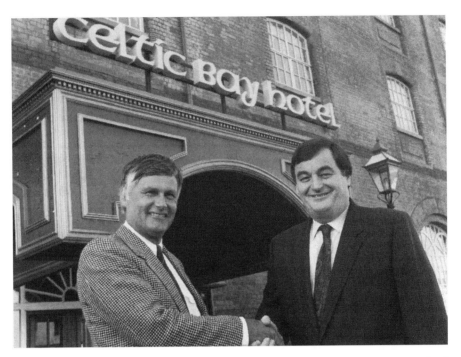

Cardiff's Celtic Bay Hotel changed ownership in 1990. In this picture is past owner Paul Aynge (left) with Mike Ludbook, Managing Director of Catering and Character Hotels. (Media Wales)

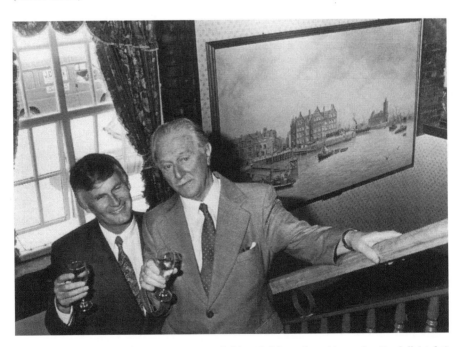

A large painting of Cardiff Bay was unveiled by Welsh author Alexander Cordell (right) at the Celtic Bay Hotel in Schooner Way in 1989. (Media Wales)

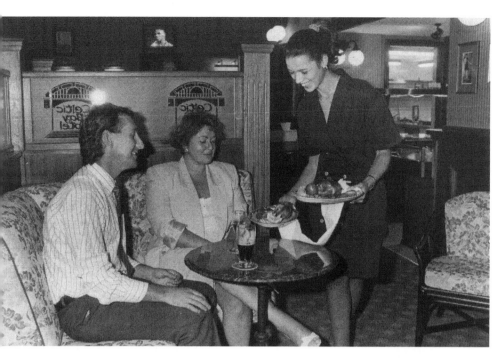

Being served in Driscoll's Bar at the Celtic Bay Hotel in 1989 are Andrew and Tina Templar from Rhiwbina. The waitress is Miss Lydia Saidi from the South of France. (Media Wales)

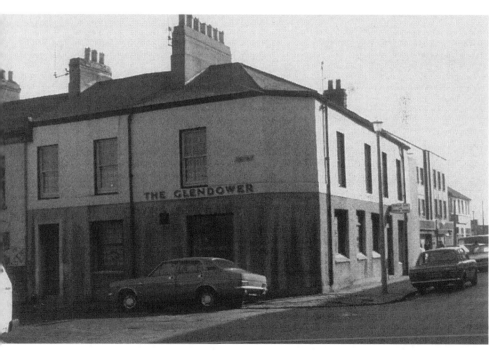

The Glendower in Crichton Street was a real working-man's pub. It dated back to 1882. (Mike O'Sullivan)

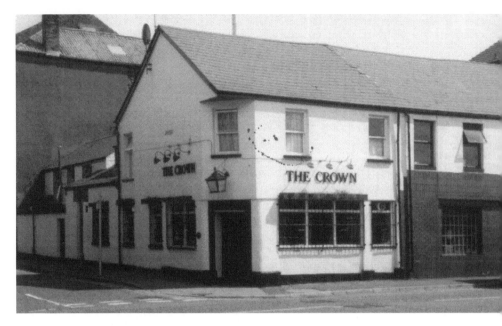

Above Thomas Rees was landlord of The Crown at 37 Bute Street in 1882. (Mike O'Sullivan)

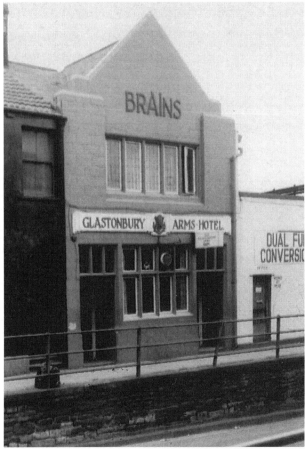

Left The landlord of the Glastonbury Arms Hotel at 25 Bute Street in 1901 was Mr A. Radmilovic. (Mike O'Sullivan)

Right The Fishguard Arms at 284 Bute Street stood next door to the Golden Cross. Mrs Mary Evans was the landlady in 1882. (Mike O'Sullivan)

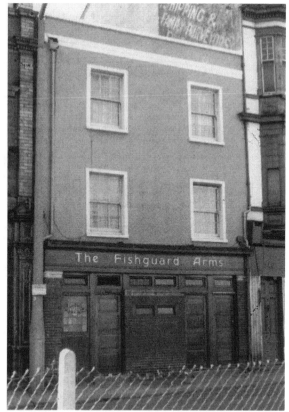

Below One of Cardiff's most historic pubs is the Packet Tavern, later known as the Packet Hotel and later still as just The Packet, refurbished in 1983. The landlord in 1882 was a Mr Juno Jacobs. (Media Wales)

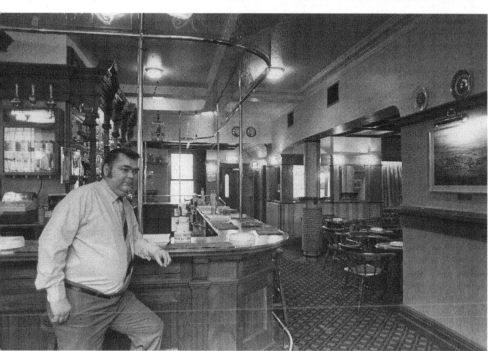

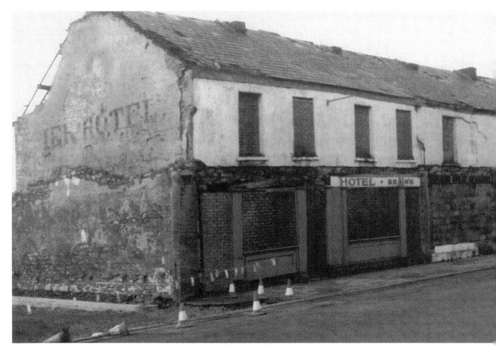

The remains of the Pier Hotel in Cardiff's docklands. It was situated at 83-84 Bute Street, and Mr D. Davies was the landlord in 1882. (Harmer Patersen)

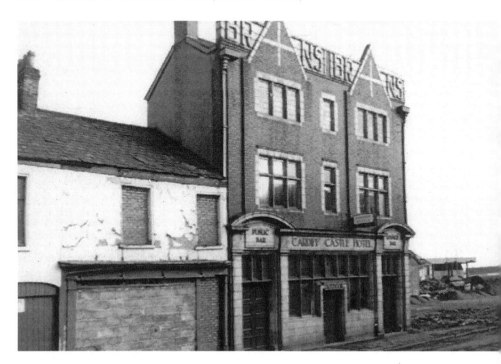

Miss Rose Parker kept the Cardiff Castle Hotel at 4-5 George Street in Cardiff's docklands in 1901. (Mike O'Sullivan)

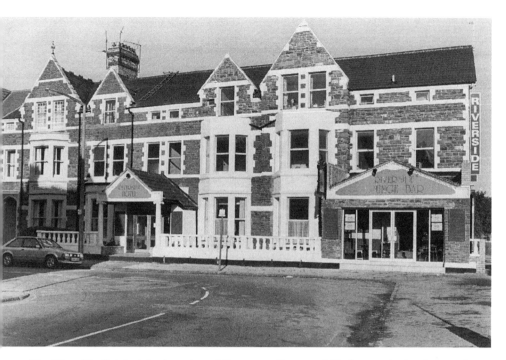

The Riverside Hotel at the junction of Despenser Street and Fitzhamon Embankment after it had been refurbished in 1985. (Media Wales)

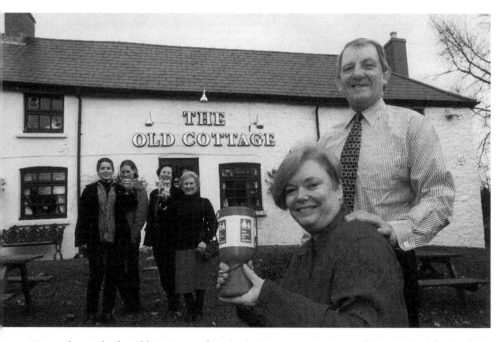

Pictured outside the Old Cottage pub in leafy Lisvane are Janice and Frank Gamble, landlady and landlord. In 1997 the pub was nominated for the national Pub of the Year award. (Media Wales)

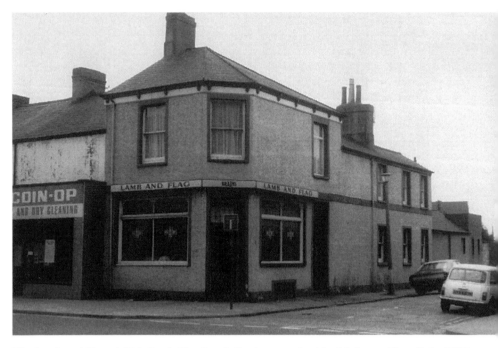

The Lamb and Flag at 211 Cowbridge Road, Canton, was kept by Mr James Howells in 1901. (Mike O'Sullivan)

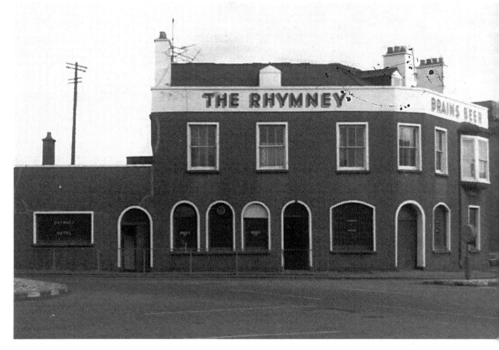

The Rhymney in Adam Street dates to 1858, and in the 1990s a new Rumples pub was built on its site. But like many other pubs throughout the country it has closed. (Authors' collection)

4

SPECIAL OCCASIONS

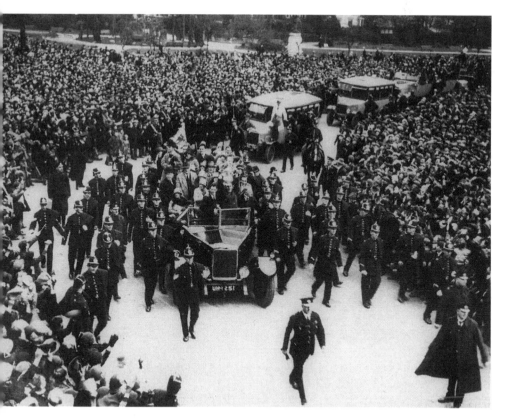

Thousands gather in Gorsedd Gardens, Cathays Park, to welcome home the Cardiff City soccer team, which won the 1927 FA Cup at Wembley. They had beaten Arsenal 1-0. (Authors' collection)

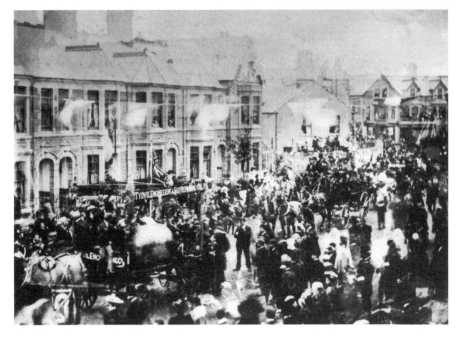

The opening of Roath Park to the public on 20 June 1894. Cardiff residents gather in their thousands along the procession route through Westgate Street, St Mary Street, High Street, Duke Street, Queen Street, Newport Road, Castle Road (now City Road) Albany Road and Wellfield Road. The procession is shown passing the last two named streets. (Authors' collection)

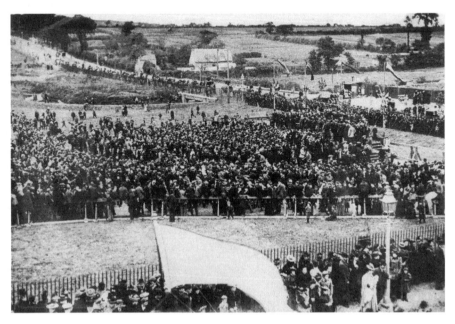

Thousands of Cardiffians wait for the Earl of Dumfries, who was celebrating his thirteenth birthday, to declare Roath Park open to the public. (Media Wales)

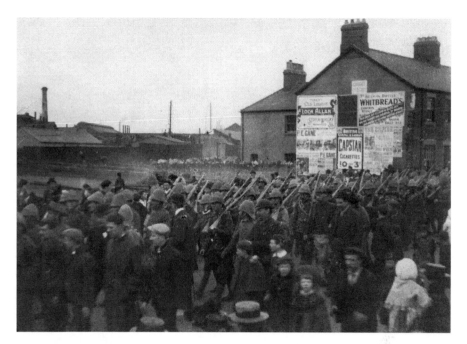

Grim-faced soldiers leaving for the Boer War. The picture was taken in the Splott area of Cardiff near Portmanmoor Road. In those days, one could have purchased ten Capstan cigarettes for just three old pence! (Authors' collection)

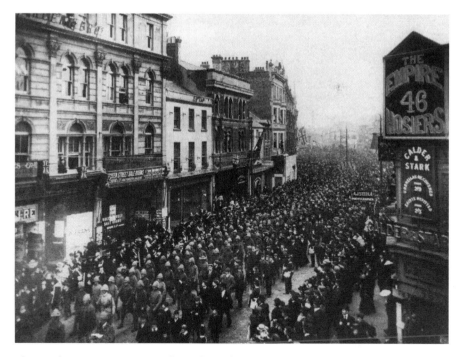

These volunteers are seen marching through Queen Street in 1902, after having served in the South African War. (Media Wales)

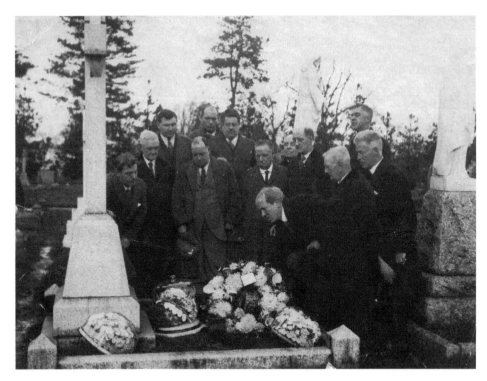

The stars of variety place a wreath on the grave of Peerless Jim Driscoll, the world-famous boxer, at Cathays Cemetery, 27 November 1928. (Authors' collection)

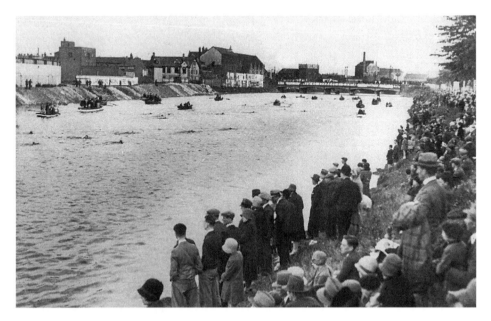

The Taff Swim viewed from Fitzhamon Embankment. This prestigious event, which dated back many years, was moved to Roath Park in 1931 but was held for the last time in 1960, owing to pollution of the lake. (Media Wales)

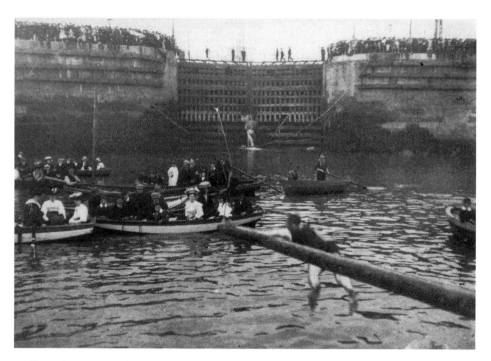

Walking the greasy pole was just one of the attractions for the thousands of Cardiffians who attended the Cardiff Docks Regatta in days long gone. (Authors' collection)

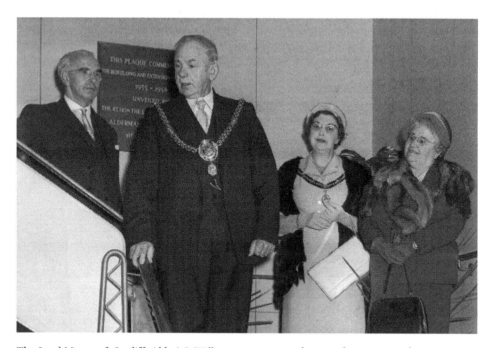

The Lord Mayor of Cardiff, Ald. A.J. Williams, is seen speaking at the opening of an extension to family store Mackross Ltd. Left to right are: Mr D.J. Davies, managing director, the Lady Mayoress Mrs Edna Williams, and Mrs D.J. Davies. 1958. (Media Wales)

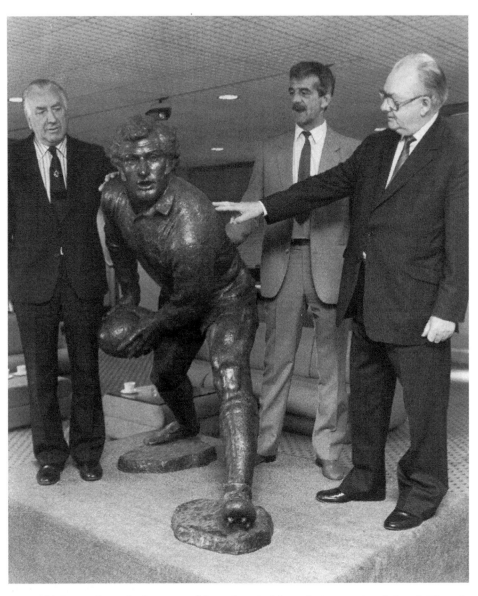

Pictured left to right, with the statue of legendary Welsh rugby international Gareth Edwards in 1990, are County Councillor Doug Francis, Chairman of the Glamorgan Sports Leisure Centre; Glyn Cluthers, Deputy Centre Manager at St David's Centre; and Lord Jack Brook, Leader of the South Glamorgan Council. The statue was on show at the Glamorgan County Hall but can now be seen in St David's Centre. (Media Wales)

5

MOVIE MAGIC

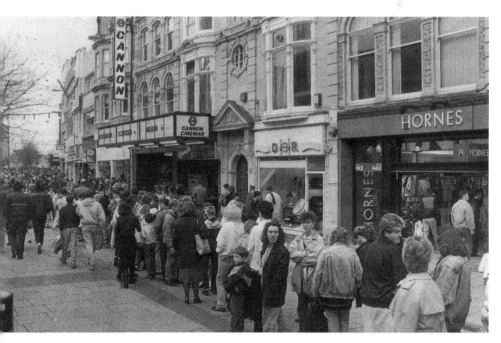

The queue outside the Cannon Cinema in Queen Street was to see the Michael Jackson film *Moonwalker*, in December 1989. (Media Wales)

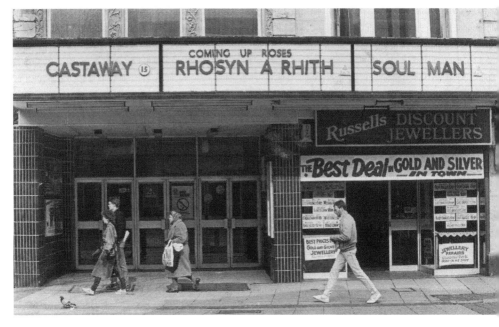

The film *Castaway* was showing at the Cannon Cinema, formerly ABC Cinema, when this picture was taken in March 1987. The cinema, like Russells Discount Jewellers (also in picture), has vanished from Queen Street. (Media Wales)

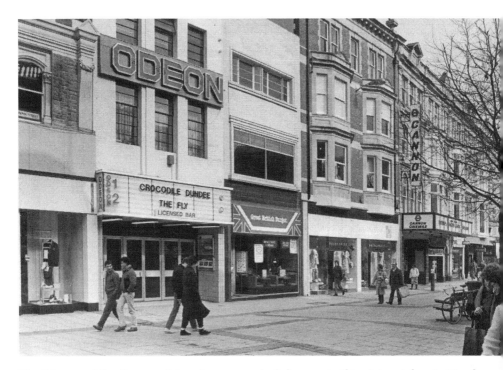

The Odeon and the Cannon picture houses can both be seen in this picture taken in March 1987. (Media Wales)

Right This picture of Kathleen Chinnick, who worked as an usherette in the Capitol Cinema, was taken in 1965. Opened in 1921, the Capitol Cinema closed in 1978 to make way for the Capitol Exchange shopping centre. (Mr Chinnick)

Below Capitol Cinema staff group picture, *c.* 1965. (Mr Chinnick)

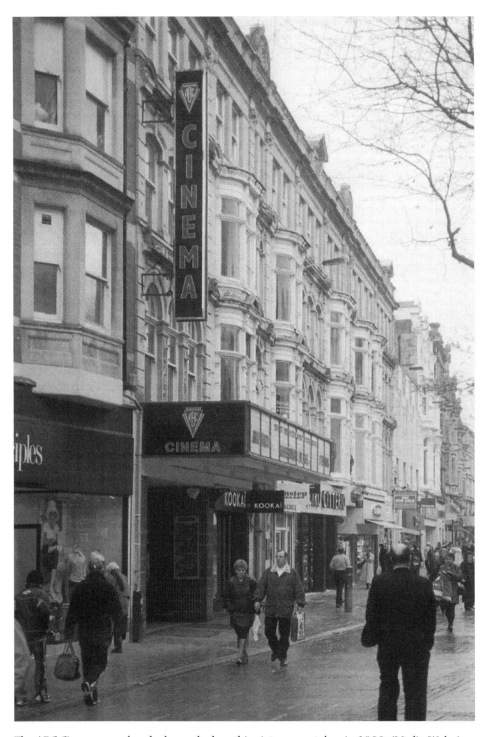

The ABC Cinema was already doomed when this picture was taken in 1999. (Media Wales)

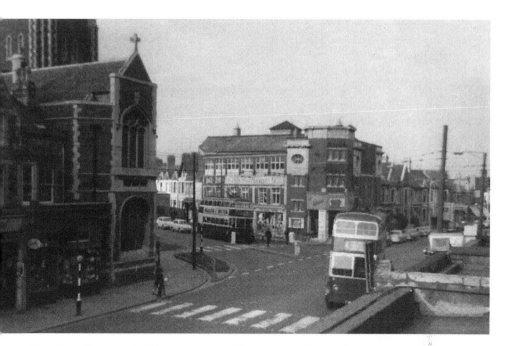

The Globe Cinema, *c.*1964. It was originally known as the Penylan Cinema, and stood on the corner of Wellfield Road and Albany Road. It was demolished in 1985, and shops and a smaller cinema were built on its site. (Authors' collection)

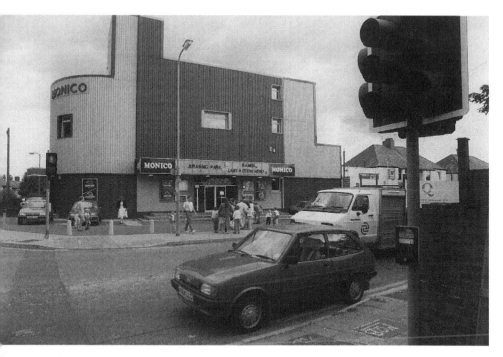

The Monico in Rhiwbina opened in 1937 and was demolished in 2003. Luxury apartments were later built on its site. (Authors' collection)

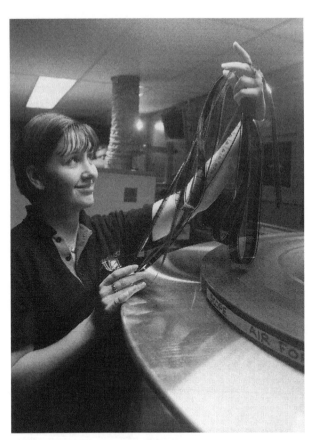

Left Margaret Smith, who is believed to have been the first female projectionist at the UCI in Atlantic Wharf, Cardiff Bay. (Media Wales)

Below One of the auditoriums at the UCI in Atlantic Wharf, Cardiff Bay. (Media Wales)

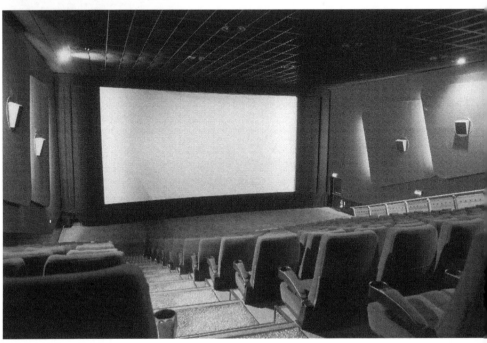

6

WHEN CARDIFF
WENT TO THE DOGS

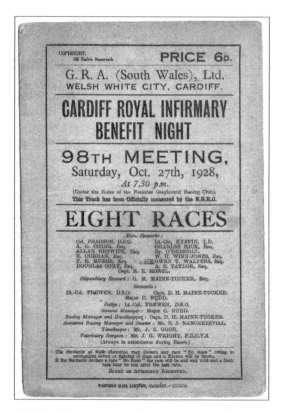

Welsh White City Stadium greyhound racing
programme for 27 October 1928. The principal
race was The Welsh Grand National, with hurdles
over 500 yards. The winner's prize was £100 and a
silver cup. (Authors' collection)

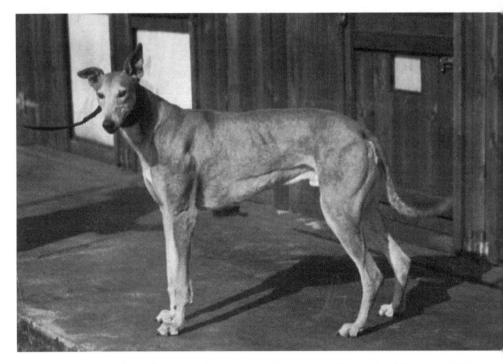

The legendary Mick the Miller, which beat the world record for the standard distance of 525 yards when competing in the 1930 Welsh Greyhound Derby at Sloper Road's Welsh White City Stadium. (Authors' collection)

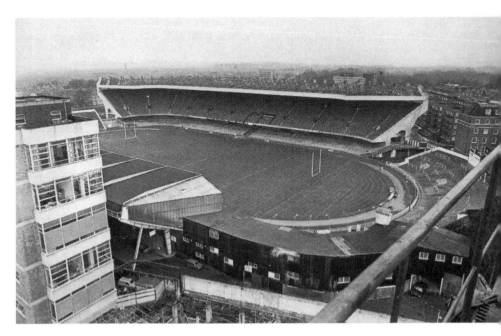

Greyhound racing was held at the Cardiff Arms Park, later known as the National Stadium, from 1928 until 1977. This picture was taken in March 1975. (Media Wales)

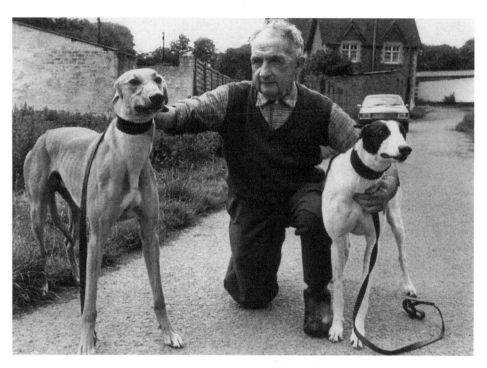

Greyhound racing trainer Freddie Goodman with Keep Smiling (left) and Malcolm Davies' Lillyput Queen (right), which won the very last race to be run at the Cardiff Arms Park in 1977. (Media Wales)

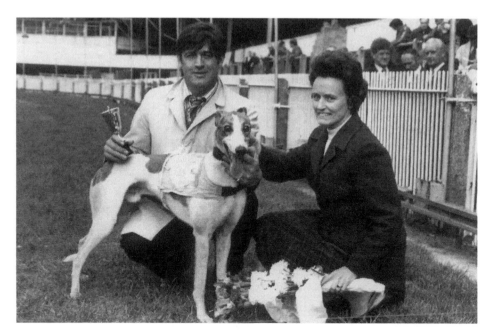

Malcolm Davies with Pride of Tudor, winner of the Double Diamond Dash at the Cardiff Arms Park in 1977. (Media Wales)

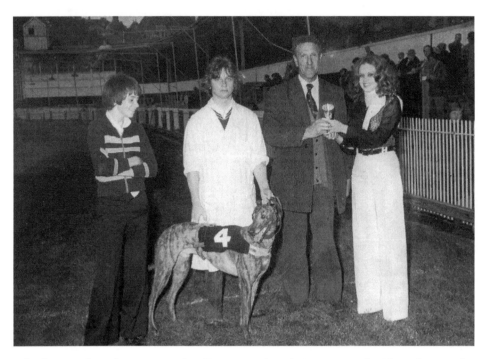

A leading greyhound trainer was Jim Barry, seen here being presented with a silver trophy, *c.* 1960. When he died in 1965, his wife Barney took over his licence and she trained many winners. These included open race winners Blackstairs Max, Sergeant Bullard and Danny's Cottage. (Barney Barry)

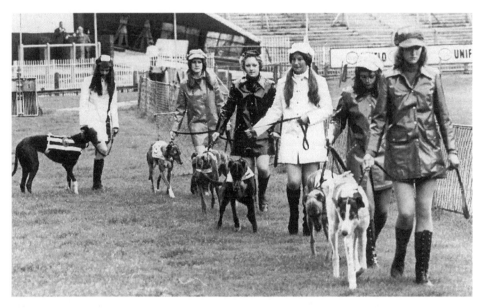

Greyhounds were always paraded before the start of their races, and in this photograph, taken in 1970, the greyhound in trap six appears to be having second thoughts about taking part! Cardiff Arms Park, *c.* 1970. (Media Wales)

7

ROYAL VISITS

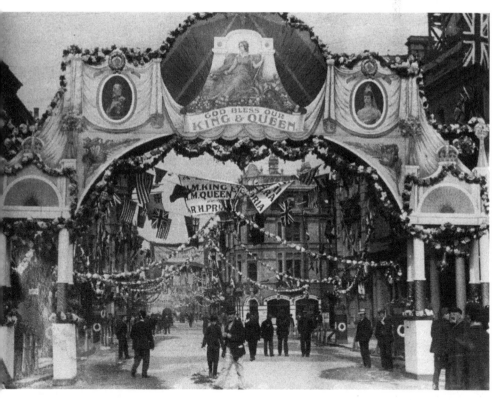

When King Edward VII and Queen Alexandra came to Cardiff to open the Queen Alexandra Dock on 12 July 1907, it was the first visit to the city by a reigning monarch for 250 years. The picture shows part of the decorated docklands route the royal carriage took on its way to the city centre. (Media Wales)

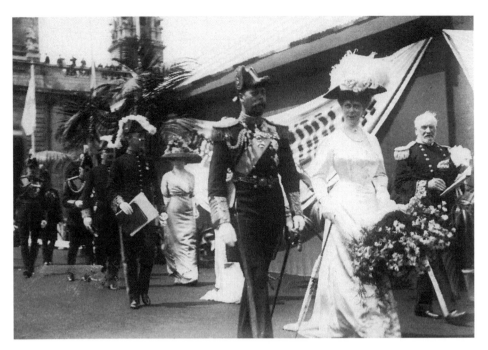

King George V and Queen Mary are seen with Lord Pontypridd (right) after the official opening of Cardiff University in Cathays Park on 25 June 1912. (Media Wales)

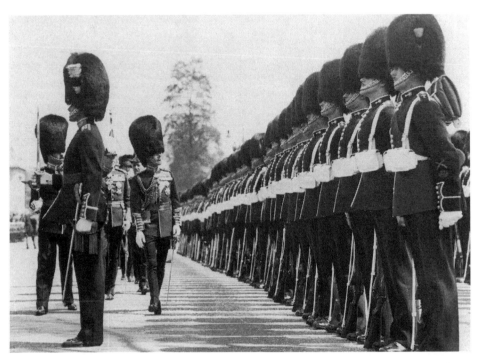

Prince Edward is seen inspecting the Welsh Guards outside the City Hall in Cathays Park on 11 May 1935. (Media Wales)

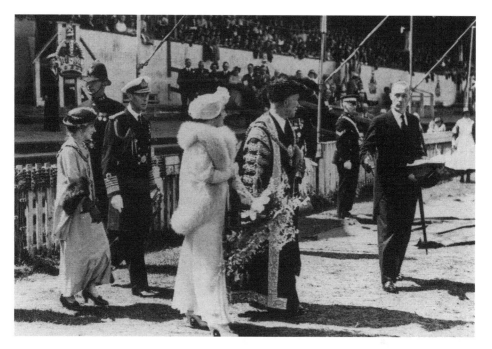

King George VI and Queen Elizabeth, seen at the Festival of Youth gathering at the Cardiff Arms Park on 14 July 1937.

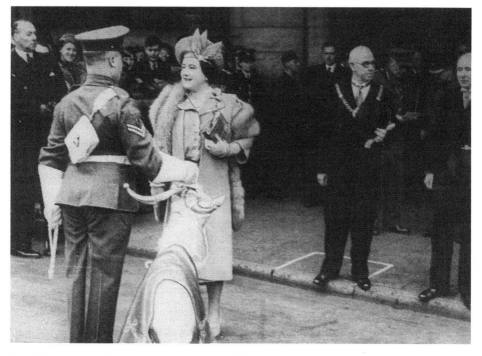

Her Majesty Queen Elizabeth paid a visit to Cardiff at the end of the war in 1945, and found time to ask the unknown Welsh Regiment corporal about the regiment's goat mascot. (Media Wales)

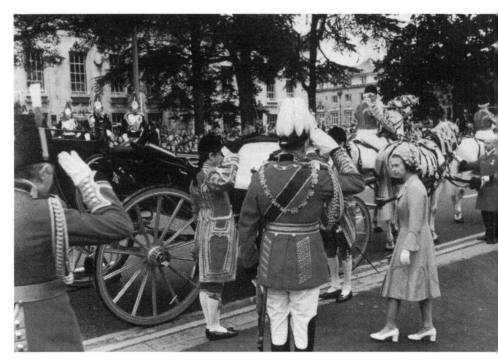

The Queen has paid many visits to Cardiff over the years, and in this picture she is seen leaving Alexandra Gardens in Cathays Park in 1955. (Media Wales)

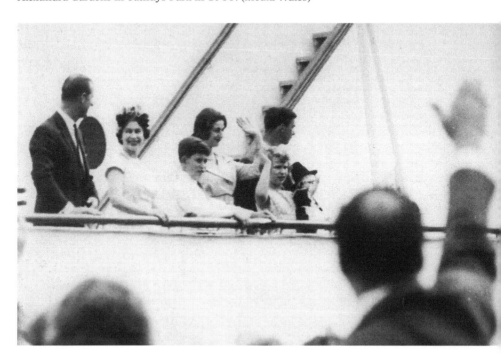

After their 1960 visit to Cardiff, the royal family leave Cardiff Docks on the *Britannia*. (Media Wales)

8

LOCAL SHOPS & STORES

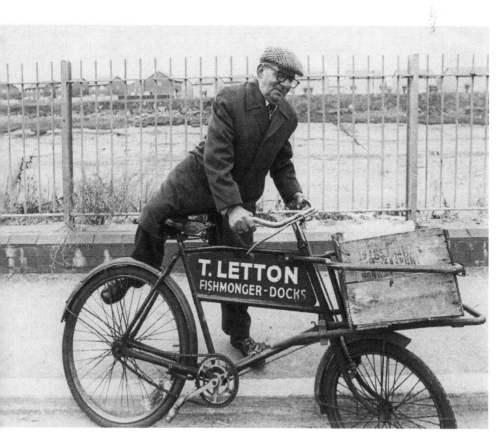

Tommy Letton, who sold fish in Cardiff's docklands for more than forty years. A street in Cardiff Bay was named after him. (Authors' collection)

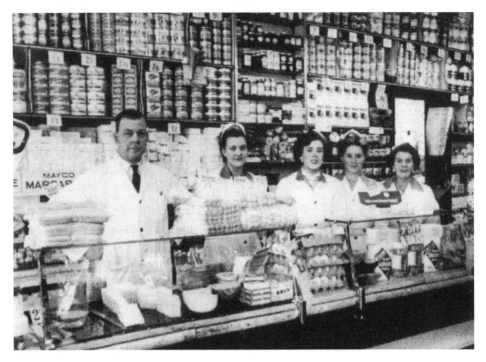

Stan Davies, manager of the Maypole in Bridge Street, with some of his staff in the 1960s. (Jeff Davies)

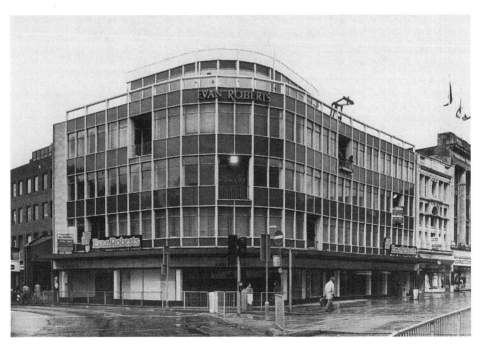

Evan Roberts' store used to be on the corner of Kingsway and Queen Street, and was up for sale when this picture was taken in 1984. (Media Wales)

Keith Twamley was the head fish and meat buyer at James Howells & Co. for around twenty-five years. (Keith Twamley)

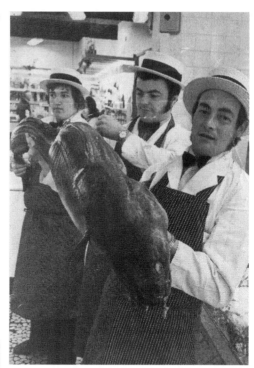

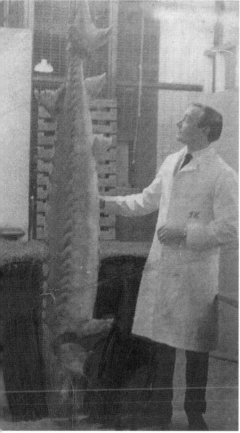

What a whopper! Keith Twamley now has his own stall at Cathedral Square in the city centre. (Keith Twamley)

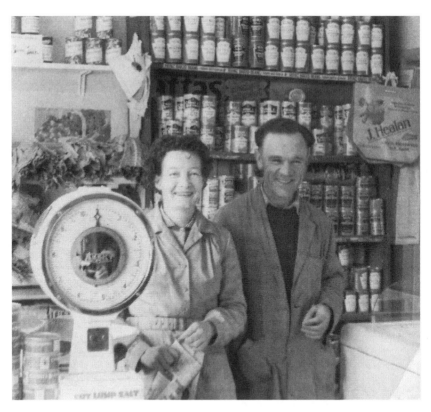

Whatever happened to all those corner grocery shops like this one in Ely, run by Mr & Mrs J. Healan? This picture was taken in 1960. (Keith Twamley)

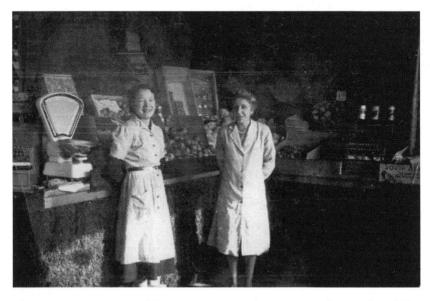

These two assistants posed for a picture in Healans grocery shop in the 1950s. (Keith Twamley)

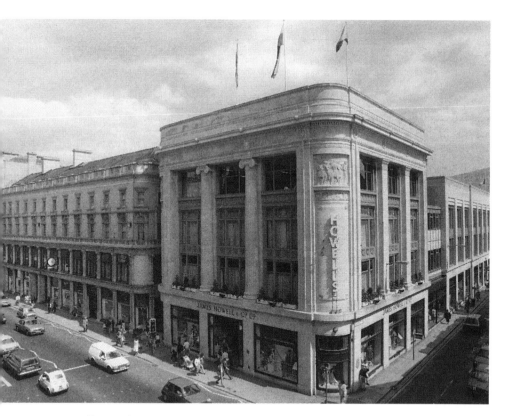

James Howell & Co. department store in St Mary Street. (James Howell & Co. Ltd)

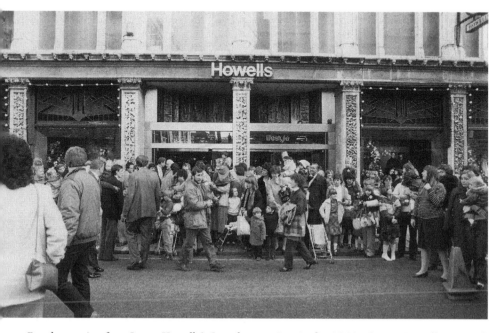

People queuing for a James Howell & Co. sale sometime in the 1960s. (James Howell & Co. Ltd)

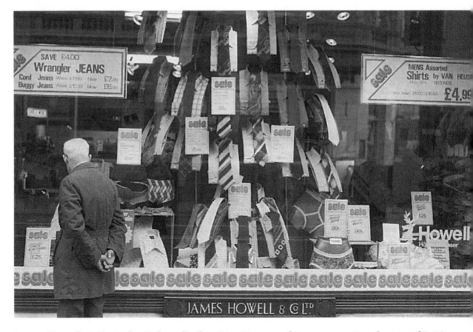

James Howell & Co. Ltd window display. Van Heusen shirts were going for just £4.99, and a pair of cord Wrangler jeans would have set you back £7.99 when this picture was taken. (James Howell & Co. Ltd)

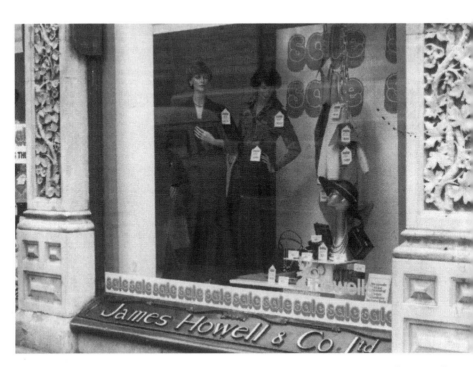

Something for the ladies! James Howell & Co. Ltd window display. (James Howell & Co. Ltd)

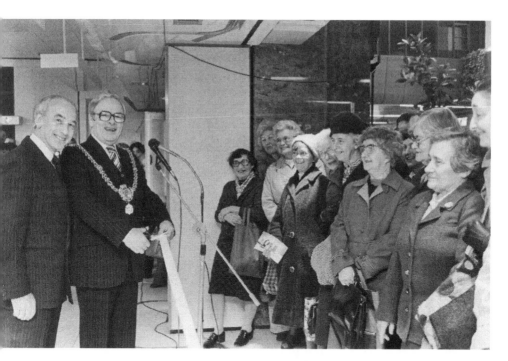

Debenhams, Wales' newest department store, was opened in St David's Centre by the Lord Mayor of Cardiff, Councillor John Edwards (seen cutting the tape) in 1981. Pictured with him is Mr Bob Thornton, the Debenhams Group chairman. (Media Wales)

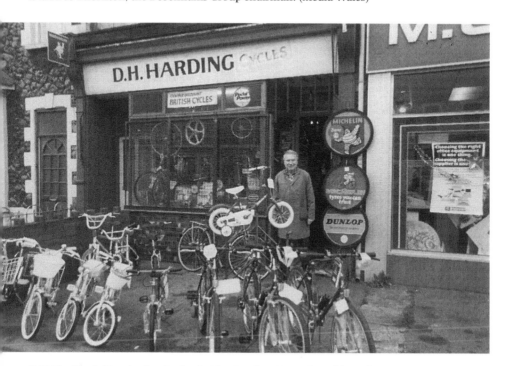

D.H. Harding's bicycle shop in Cowbridge Road, *c.* 1960. (Gerald May)

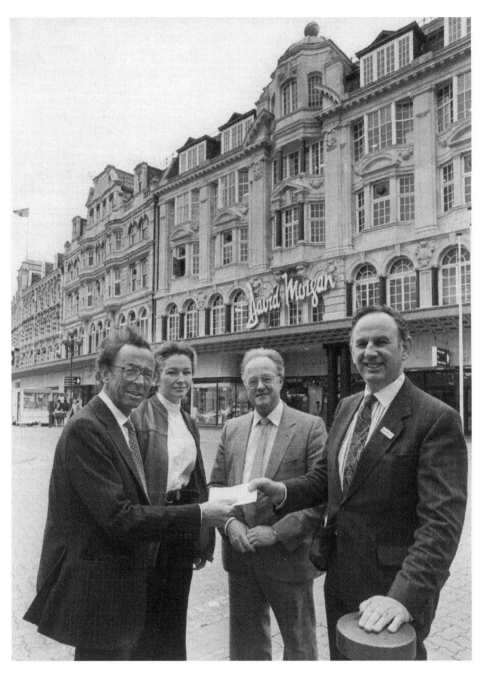

Mr John Morgan, right, managing director of David Morgan Ltd on The Hayes, receives a cheque for £11,053 to help pay for the restoration of the store's famous façade in 1987. The cheque, a grant from Cardiff City Council and the Welsh Office, is presented by Councillor Julius Hermer, chairman of the city's planning and development committee. Looking on are Miss Jessica Geddes of Cadw and Mr Eurfyl Davies, the city's planning and development officer. (Media Wales)

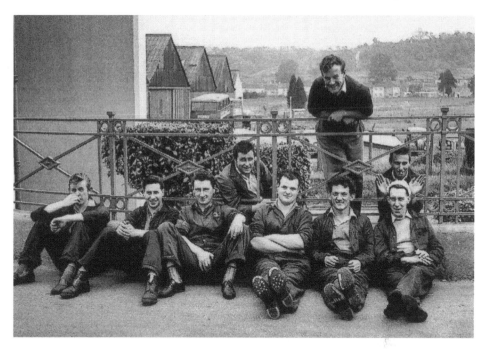

Workers from the Western Welsh Company at the Ely depot, *c.* 1960. Left to right sitting down are Les Griffiths, Keith Duggan, Terry Foreman, Patrick Bridges, John Reynolds, Dougie Dixon, Graham Parsons and Tommy 'Eggs' Jenkins, showing his hands. (Allan Watson Rees)

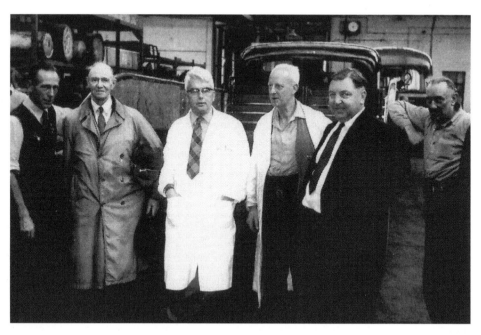

Left to right are: Stan Self, George Irons, Albert Errington, Percy Pidgeon (the factory foreman), Les Gray (assistant engineer) and Ernie Murphy. This picture was taken in 1966. (Allan Watson Rees)

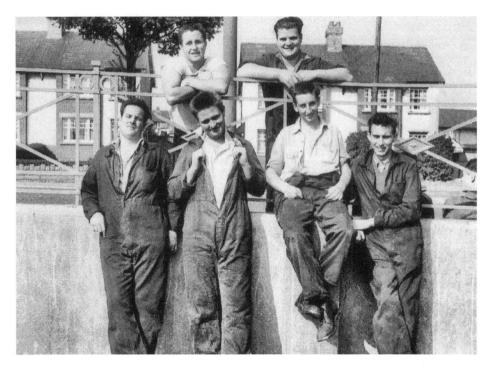

Left to right are: Ron Gillingham, Gordon 'Thatch' Littley, Mike 'Alfonso' Gadd and Tommy 'Eggs' Jenkins. The two workers the other side of the railings are Patsy 'Fagan' Bridges and John Reynolds. (Allan Watson Rees)

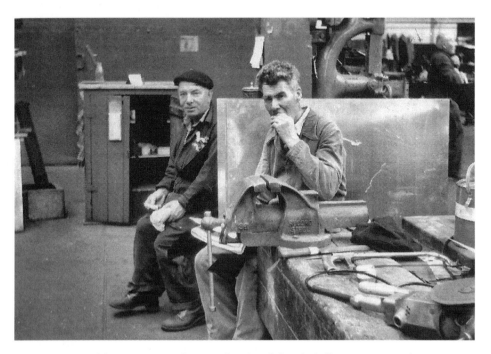

Two Western Welsh Company workers on their lunch break. (Allan Watson Rees)

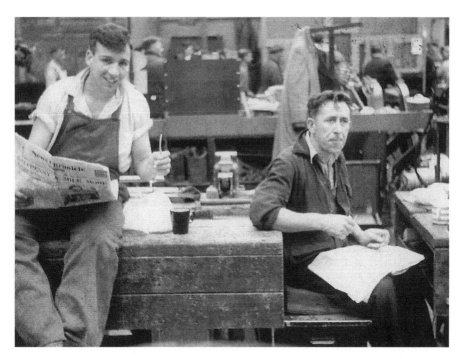

Two workers from the Western Welsh Company on a lunch break, *c.* 1966. The man on the left is reading the long gone morning newspaper the *News Chronicle*. (Allan Watson Rees)

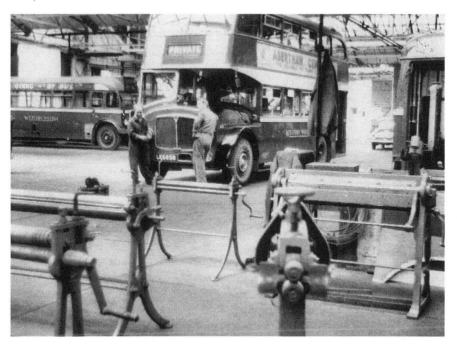

Buses awaiting repairs at the Western Welsh Company depot, *c.* 1960. (Allan Watson Rees)

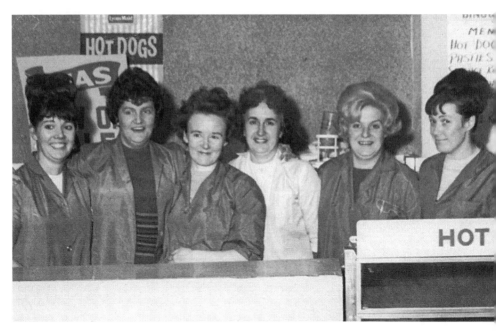

This picture of the staff at Gaiety Bingo was taken during the 1960s. (Ron Gillingham)

Staff of the British Lion Film Company posed for this picture in St David Street, where the company had an office in the 1950s. (Ron Gillingham)

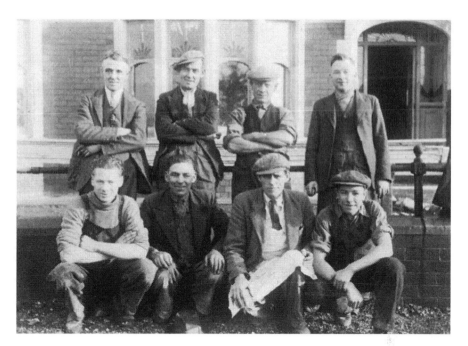

Cardiff builder Eddie Williams built many houses in the Rhiwbina, Llanishen and Heath areas of Cardiff in the 1920s and '30s. He is seen here standing first on the left with his building gang. A former professional athlete, in 1921 he won the then world-famous Welsh Powderhall Sprint at Taff Vale Park in Pontypridd. (Authors' collection)

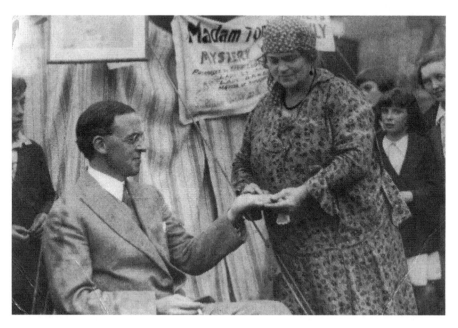

Madam Toledo, a fortune teller who was based in Cardiff Central Market, is seen here at a charity fête reading the palm of Sir Stafford Cripps, then Chancellor of the Exchequer of Clement Attlee's government, *c.* 1947. (Ron Marsh)

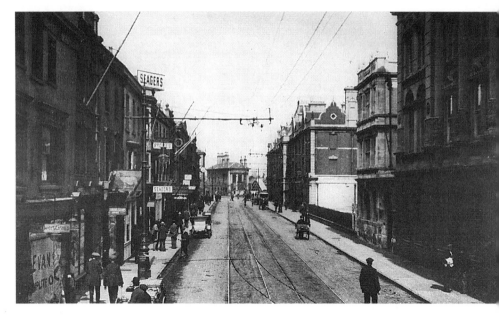

Bute Street had a number of little shops and businesses when Ernest T. Bush took this picture postcard scene. The tramlines tell us that it was taken sometime after 1902. (Ernest T. Bush)

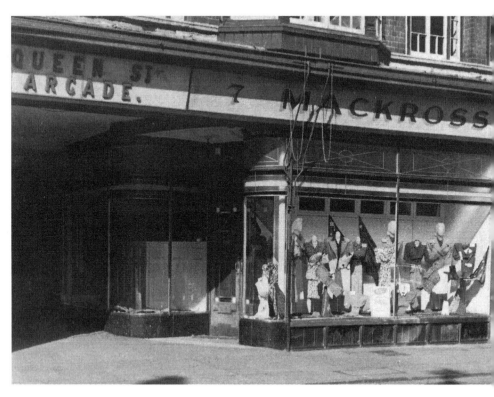

Mackross was situated in the old Queen Street Arcade, although the shop window in this picture is actually in St John Street. This photograph was taken in 1950. (Authors' collection)

9

SCHOOLDAYS

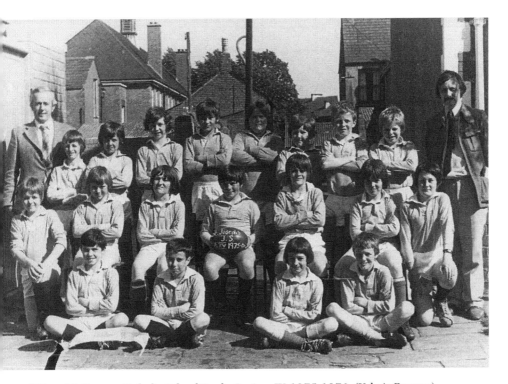

St Joseph's Roman Catholic School Rugby Juniors IV, 1975-1976. (Valerie Beames)

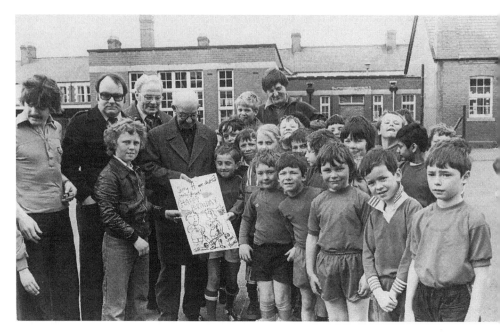

Mr H.K. Harries receives a special birthday card from pupils of Gladstone School. Presenting the card are Paul Corsi (left) and Anthony Ullah (right). (Authors' collection)

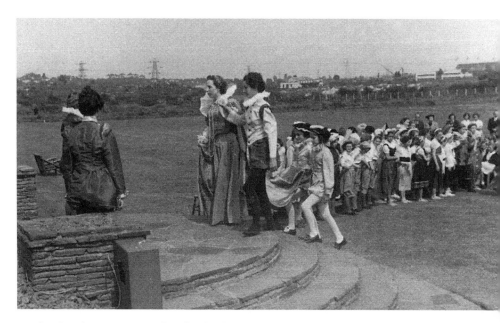

Pupils of Lady Margaret High School take part in an Elizabethan pageant in June 1953. (Margaret Aven, *née* Babbage)

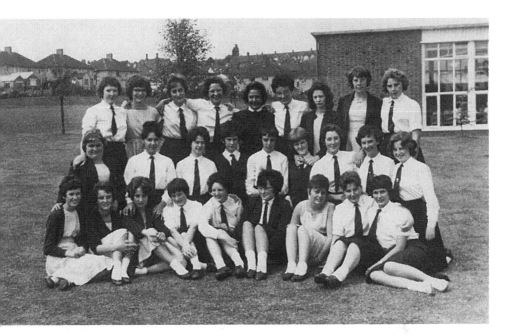

Pupils of Lady Margaret High School, which used to be in Colchester Avenue and was demolished some time ago. The picture was taken in September 1955. (Margaret Aven, *née* Babbage)

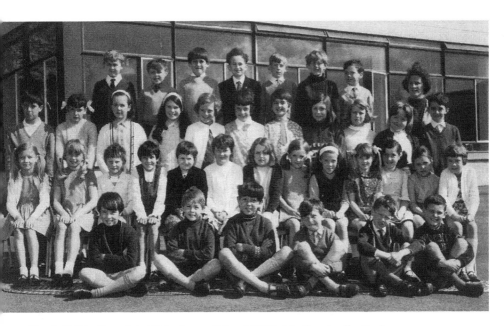

Llandaff City Church in Wales Junior School 1969. (Authors' collection)

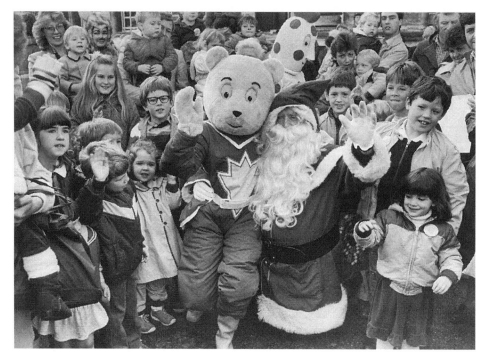

Father Christmas, along with SuperTed and Spotty, arrived at the SuperTed Christmas Grotto at James Howell & Co. Ltd in November 1984. (Authors' collection)

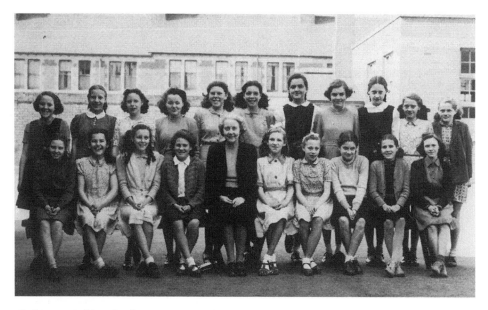

Gladstone Girls' School, Form 2. In this picture from 1947 are: M. Davies, A. Fisher, A. Harwood, G. Rees, D. Tullett, T. Gammon, M. Jones, S. Lloyd, B. Morgan, E. Bazley, M. Jones, S. Blzcht, M. Williams, P. Downs, S. Edwards, Miss Rees, S. Collins, G. Davies, B. Bona, J. Holley, and D. Howard. (Authors' collection)

Right These three eleven-year-old Gladstone Junior School pupils – Phillippa Cole, Sharon Steadman and Lisa Saltmarsh – formed a dancing and entertainment group called The Dancing Dolls. Unfortunately the date is unknown. (Media Wales)

Below Kitchener Road Boys' School Football Team 1930-1931. (Jason Walters)

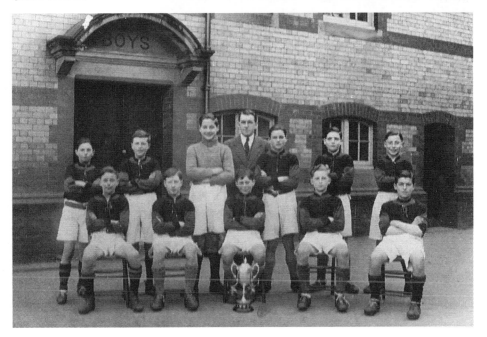

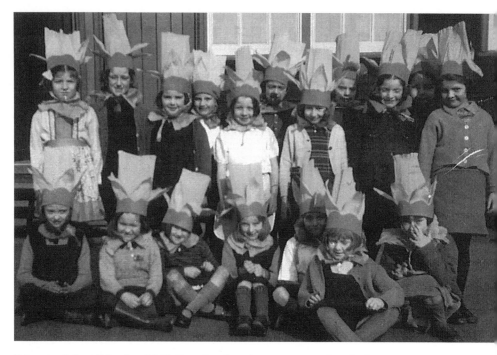

Fairwater Infant School, *c.* 1940. June Franks, *née* Burn, is seated in the front row, second from right. (Sharon Franks)

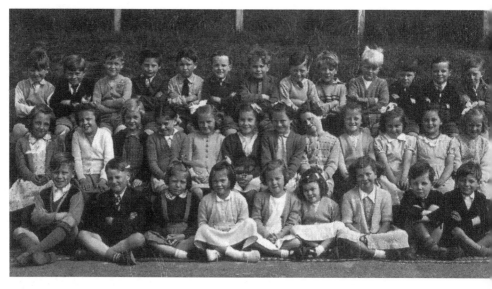

Fairwater Infant School, *c.* 1953. John Donovan can be seen in the back row, fourth from left. (Sharon Franks)

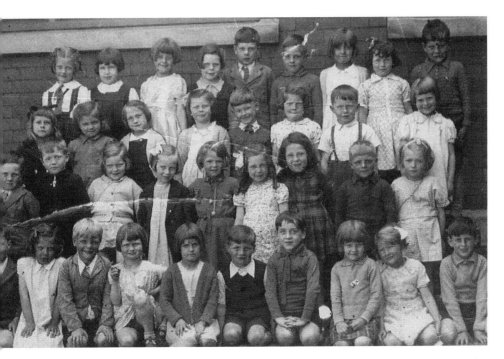

Herbert Thompson School in Ely, *c.* 1940. Seated in the front row, third from left, is June Franks, *née* Burn. (John Donovan)

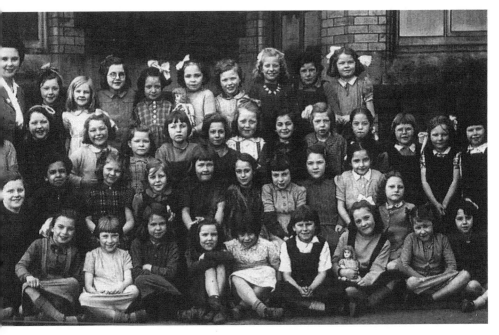

Moorland Road School in Splott. The little girl second from the left in the second row from bottom is the now world-famous singer Dame Shirley Bassey. (Suzanne Donovan)

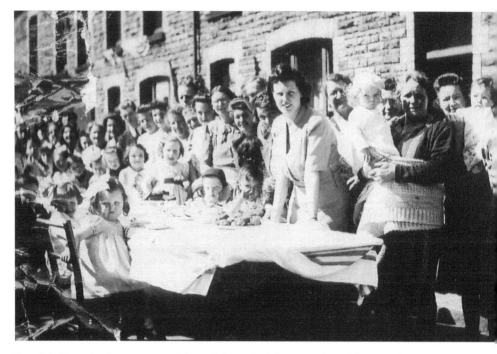

Ferndale Street in Grangetown celebrated the end of the Second World War with a street party. The little girl to the front of the picture is Patricia Cole, *née* O'Halloran. Opposite her, the lady with her hands resting on the table is her mother, Monica O'Halloran. (Patricia Cole)

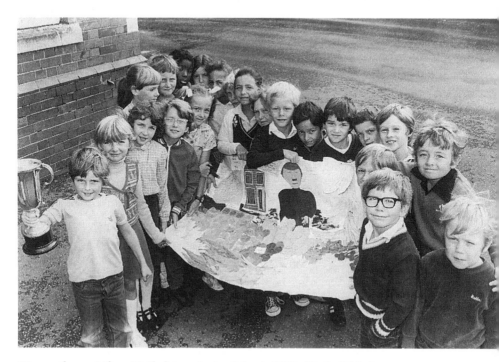

We won the cup! Class 1P Gladstone Junior School, 1979. (Media Wales)

10

SPORTING MOMENTS

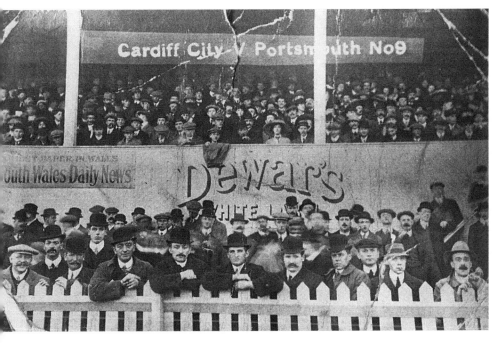

Cardiff City played Portsmouth at Ninian Park sometime in the early 1900s. Can you spot a supporter who is not wearing a hat or cap in this picture? (Authors' collection)

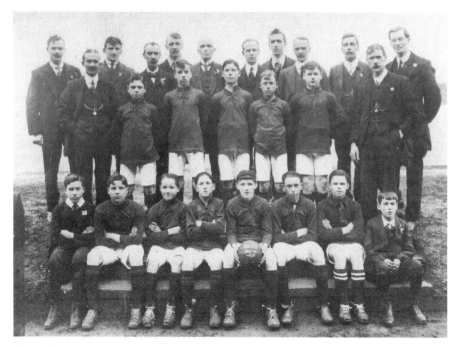

The Wales 1915-1916 junior soccer team. (Authors' collection)

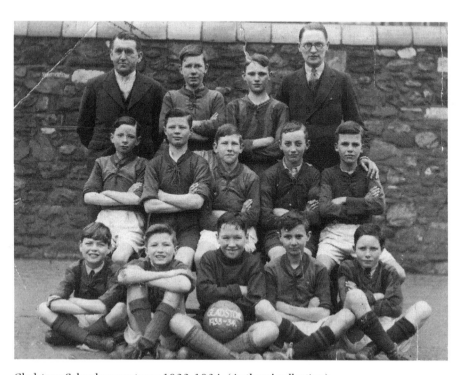

Gladstone School soccer team 1933-1934. (Authors' collection)

Albany Road Boys' School soccer team 1934-1935. Head teacher Mr Craze is on the left and teacher Bob 'Pop' Roberts is on the right. (Authors' collection)

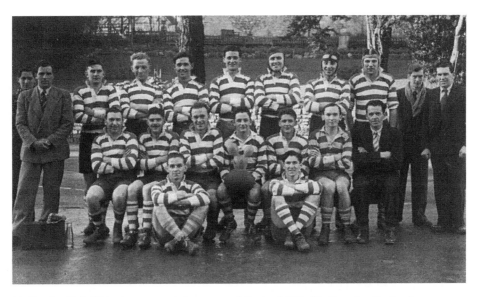

Ely Rugby Club. This picture was taken around Easter 1951. (Authors' collection)

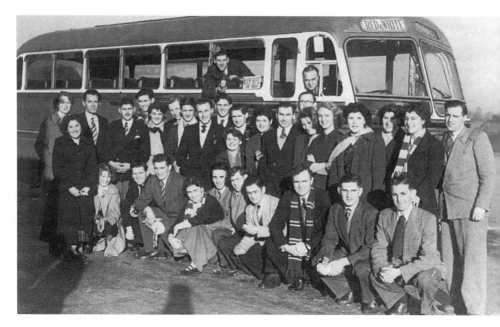

Ely Rugby Club supporters' trip to Gloucester in 1951. (Authors' collection)

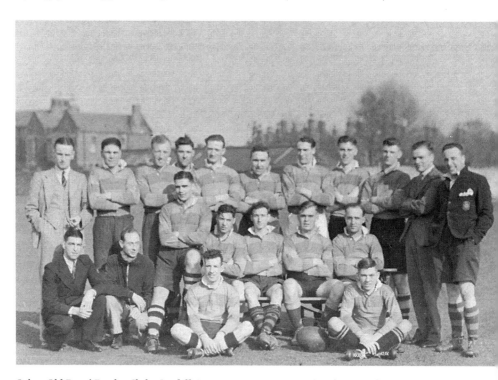

Splott Old Boys' Rugby Club, Cardiff & District, 1937-1938. (Authors' collection)

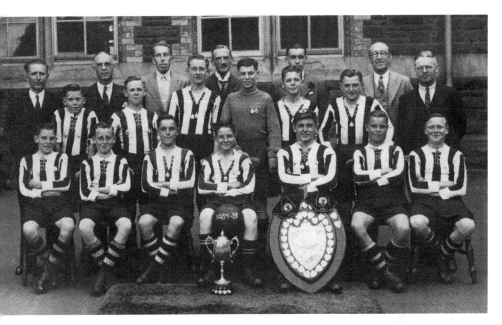

Moorland Road Cup and League winners 1937-1938. (Authors' collection)

Connies & Meaden Team, 7th division League winners, *c*.1950. (Authors' collection)

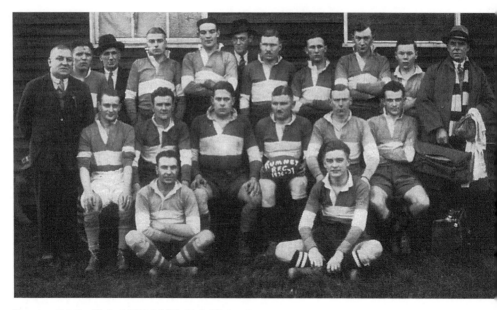

Rumney Rugby Club, 1936-1937. (Bob Watson)

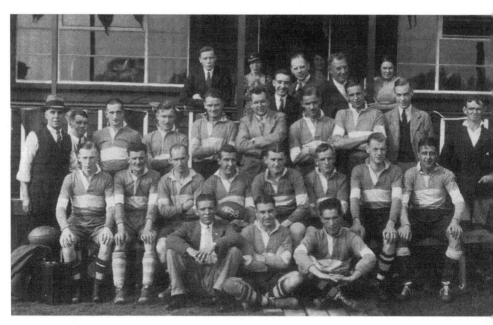

Rumney Rugby Club, *c.* 1930. The team played at Rumney Hill Gardens, off Newport Road, Cardiff. (Bob Watson)

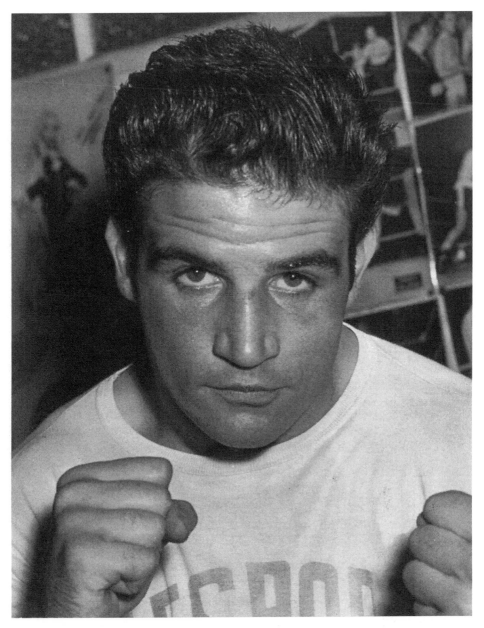

Born in 1936, boxer Phil Edwards was Welsh Middleweight Champion from 1957 until 1962. Due to his good looks, he was dubbed 'the Marlon Brando of Wales'. (Media Wales)

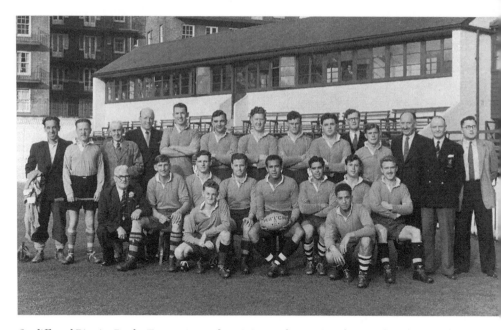

Cardiff and District Rugby Team, pictured on 3 September 1952. The man kneeling on the left is Harry Parfitt, a well-known Cardiff rag and bone man who was involved with boxing clubs, football teams and raising money for local charities. (Leslie W. Hansen)

Cardiff and District Rugby Team, 1 September 1955. The Westgate Street flats can be seen in the background. (Leslie W. Hansen)

Cardiff and District Rugby Team, 27 September 1961. (Leslie W. Hansen)

The 'Reds' team. Cardiff Combination Junior Trial at Llandaff Fields, 1957. (Media Wales)

Viriamu Jones School soccer team, 1957-1958. (Authors' collection)

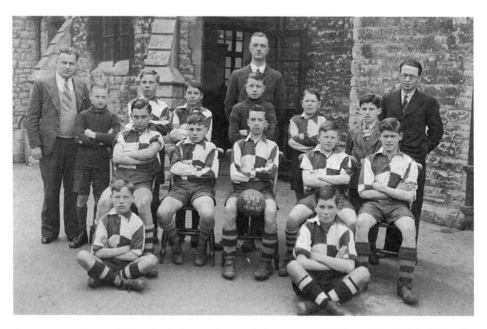

Grangetown National School. Undefeated school champions, Division 111, 1934-1935. (A. McGlynn)

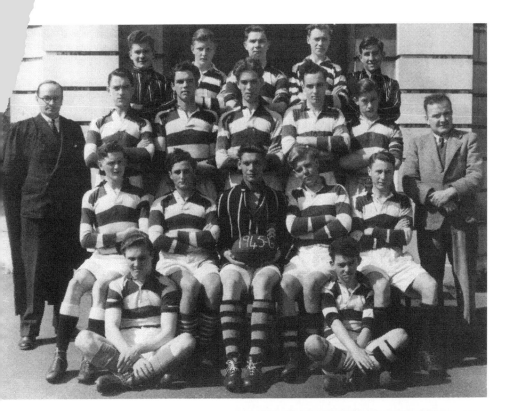

Above Cardiff High School, 1st XV,
1945-1946. (Authors' collection)

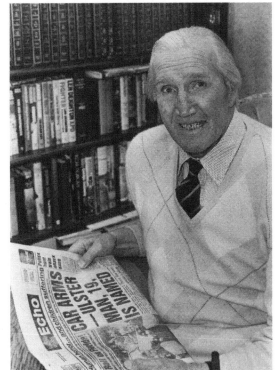

Right Cardiff-born former British
boxing Heavyweight Champion Jack
Petersen, pictured at his Porthcawl
home after having a chest operation
in 1990. Born in 1911, he died
shortly after this picture was taken.
(Media Wales)

If you enjoyed this book, you may also be interested in...

Cardiff Then & Now
BRIAN LEE & AMANDA HARVEY

The industrial revolution had an enormous effect on Cardiff
and South Wales, and many landmarks from that era are
now either gone or almost unrecognisable. The authors take
us on a fascinating trip down memory lane by using modern
photographs taken from the same spot as those taken a
century ago. These pictures have been placed side-by-side,
showing just how much the city has changed and how much
it continues to evolve even now.

978 0 7524 7113 6

A Postcard from Cardiff
BRIAN LEE & AMANDA HARVEY

The changing face of Cardiff is revealed through a selection of
archive postcards, which bring the rich history of the town to
life. Brian Lee and his daughter Amanda Harvey are experts
on the city, and trace its evolution from the industrial and
commercial districts to the people and their changing tastes in
entertainment, fashion and pastimes. This book is a must-read
for anyone who knows and loves this fascinating city.

978 0 7524 5836 6

Roath, Splott and Adamsdown
JEFF CHILDS

Jeff Childs charts the history of three districts of Cardiff, tracing
their journey from pre-Norman rural settlements to thriving
commercial centres. Personal testimonies from inhabitants
throughout the centuries create a vivid, personal view of
society and the changing environment. The author looks at
industrial development, religion, education and their effects on
families, from the early days right up to the modern era.

978 0 7524 5864 9

Visit our website and discover thousands of other History Press books.

www.thehistorypress.co.uk